The College History Series

SOUTHERN ILLINOIS UNIVERSITY
EDWARDSVILLE

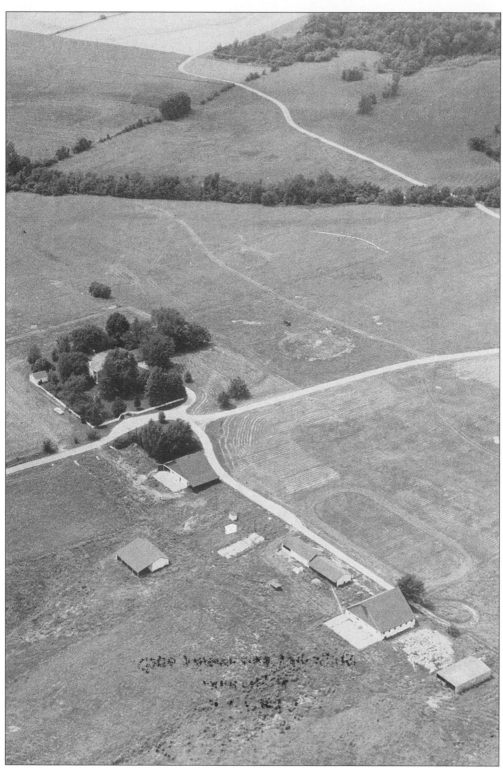

The Freund property became the core of the Edwardsville campus.

The College History Series

SOUTHERN ILLINOIS UNIVERSITY
EDWARDSVILLE

STEPHEN KERBER AND DONNA YATES BARDON

ARCADIA

Published by Arcadia Publishing,
an imprint of Tempus Publishing, Inc.
3047 N. Lincoln Ave., Suite 410
Chicago, IL 60657

Printed in Great Britain.

Library of Congress Catalog Card Number: 00-108018

For all general information contact Arcadia Publishing at:
Telephone 843-853-2070
Fax 843-853-0044
E-Mail sales@arcadiapublishing.com

For customer service and orders:
Toll-Free 1-888-313-2665

Visit us on the internet at http://www.arcadiapublishing.com

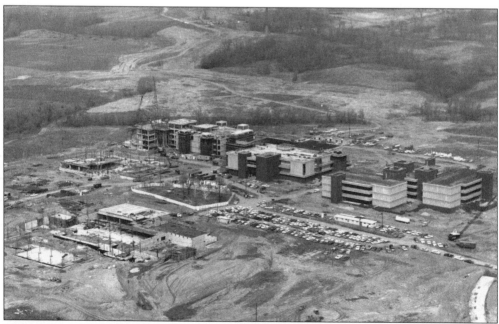

The original five buildings included, in counterclockwise order, the John Mason Peck
Building, Elijah Parish Lovejoy Library, the Science Building, the Communications
Building, and the University Center.

CONTENTS

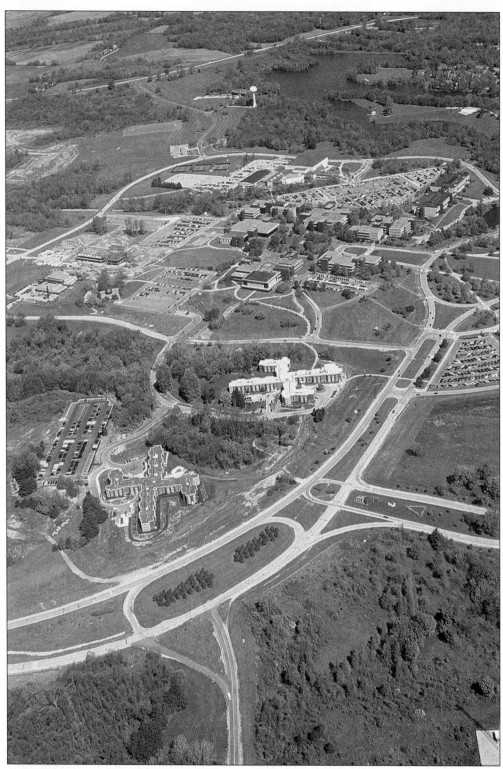

An aerial view revealed the growth of the campus through 1999.

One

THE RESIDENCE CENTER ERA

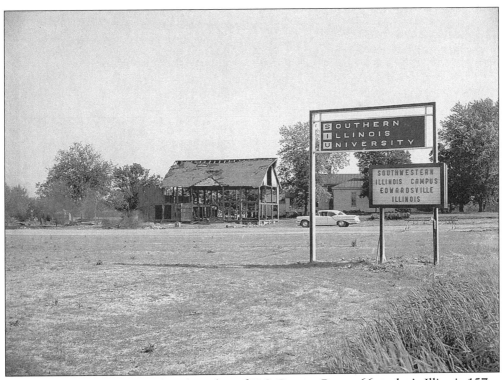

The first campus sign stood at the edge of U.S. Bypass Route 66, today's Illinois 157.

The SIU Board of Trustees designated the old East St. Louis High School building as a residence center on January 17, 1957.

The Board of Trustees also named the former Shurtleff College in Alton as a residence center on January 17, 1957. The Science Building became a focal point for classroom and laboratory activity.

Dean of Instruction William Going posed at his desk in the former Gerling home on Fangenroth Road. Dean Going recruited and hired many of the initial residence center faculty.

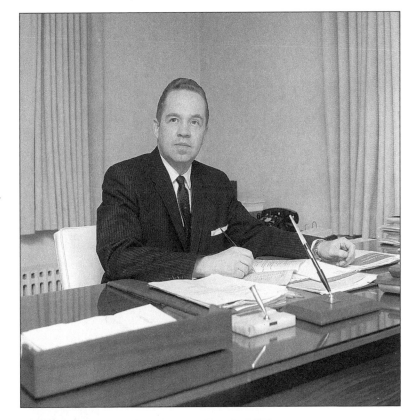

As director of the Belleville residence center, Harold See coordinated local efforts to persuade the SIU trustees to offer courses in Alton and East St. Louis. As vice president of the Southwestern Illinois campus, he led the regional drive to pass the Universities Bond Issue in 1960. He moved his administrative offices to Edwardsville on December 18, 1959.

9

This photograph of the first Edwardsville graduation, June 14, 1960, took place on property acquired before the passage of the November 8 bond issue. This view looked from Bypass 66 to the northwest and revealed the graduates, audience, and the makeshift stage.

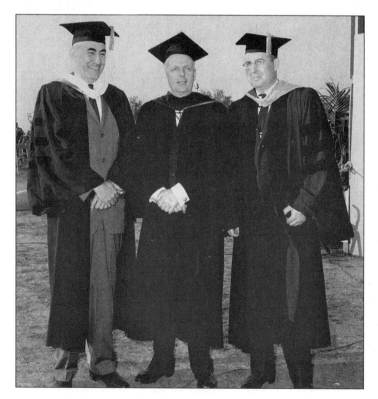

Pictured, from left to right, are SIU President Delyte Morris, Illinois Governor William Stratton, and Vice President Harold See as they stood together at graduation, 1960. Governor Stratton, who supported passage of the bond issue, served as commencement speaker.

The university acquired the title to the interurban railroad right-of-way across the Edwardsville campus from the Illinois Terminal Railroad Company on October 30, 1959.

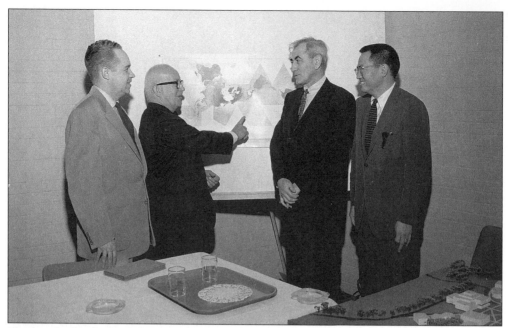

Shown here, from left to right, are : Dean William Going, Buckminster Fuller (Carbondale research professor), President Delyte Morris, and Gyo Obata (chief Edwardsville campus designer) of Hellmuth, Obata, and Kassabaum.

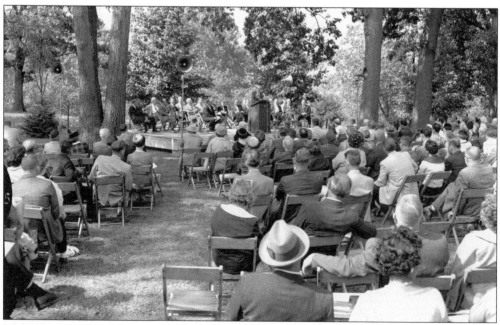

More than 1,500 visitors attended a public rally in support of the Universities Bond Issue on October 3, 1960.

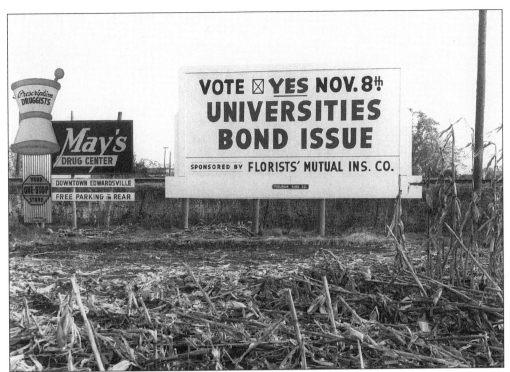

A prominent billboard promoting passage of the bond issue stood east of Bypass 66, across from the campus.

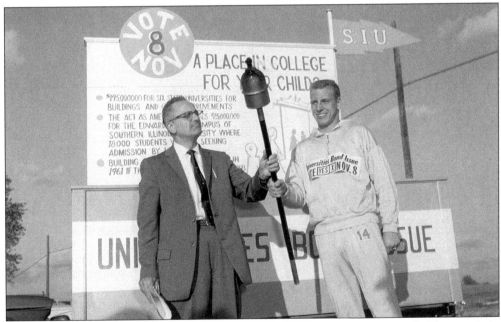

Director of Student Affairs Howard Davis (left) and a student runner held a torch in anticipation of the November 2–5, 1960 marathon.

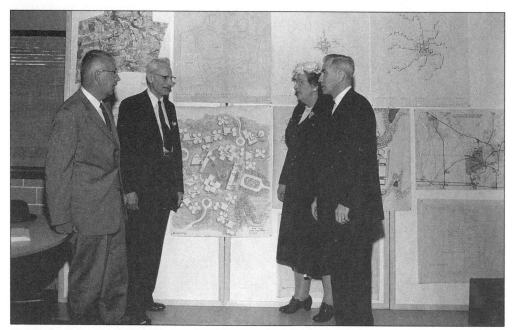

Dr. Robert Lynn (left), Alton physician and president of the Southwestern Illinois Council for Higher Education, examined campus plans with SWICHE officers George Moorman (center) and Bernice Goedde, and President Delyte Morris (right).

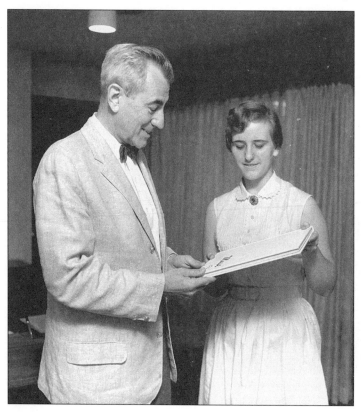

Editor Carole McDonald presented a copy of the first (1961) Edwardsville *Muse* yearbook to President Delyte Morris. Mary Margaret Brady, advisor to the 1961 yearbook staff, became the first woman at the Edwardsville campus to attain the rank of professor on June 28, 1963.

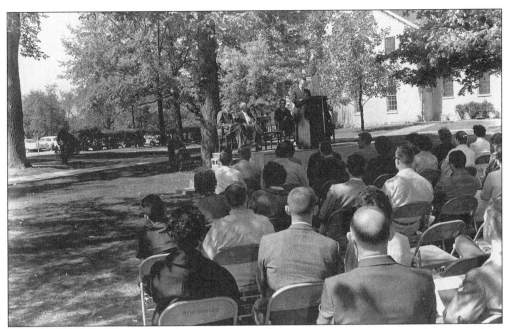

Students and faculty participated in an outdoor Honors Day program at the Alton Residence Center in 1961.

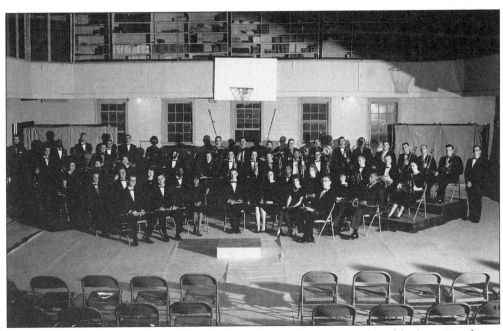

The Concert Band, conducted by C. Dale Fjerstad, posed in the old Alton Residence Center gym.

15

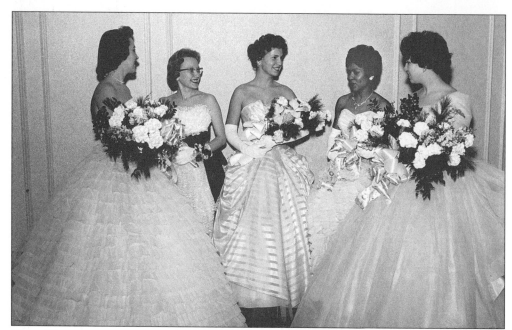

Mary Allen (center) appeared as Miss Southwestern, Queen of the 1960 Holiday Ball. Her attendants included, from left to right: Janice Cook, Maryann Frehes, Wanda Armistead, and Cece Peskar.

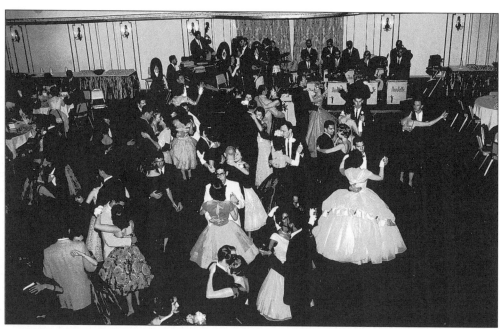

Dressed in formal attire, students danced at the 1960 Holiday Ball. These functions usually took place at hotels in downtown St. Louis.

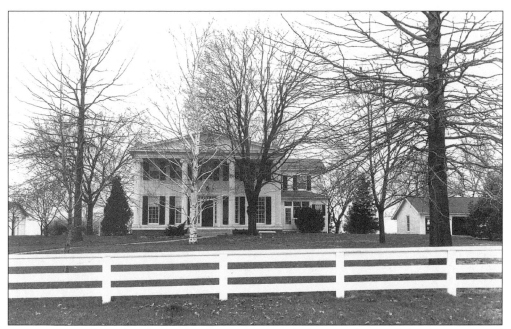

On January 16, 1961, the university announced the purchase of the key piece of property for the Edwardsville campus, the 132-acre Freund farm, for $155,000. Approximately 1,400 acres had previously been purchased.

The June 15, 1961 graduation, pictured here, took place outdoors at a site near the Freund house and farm buildings, as did the June 14, 1962 commencement.

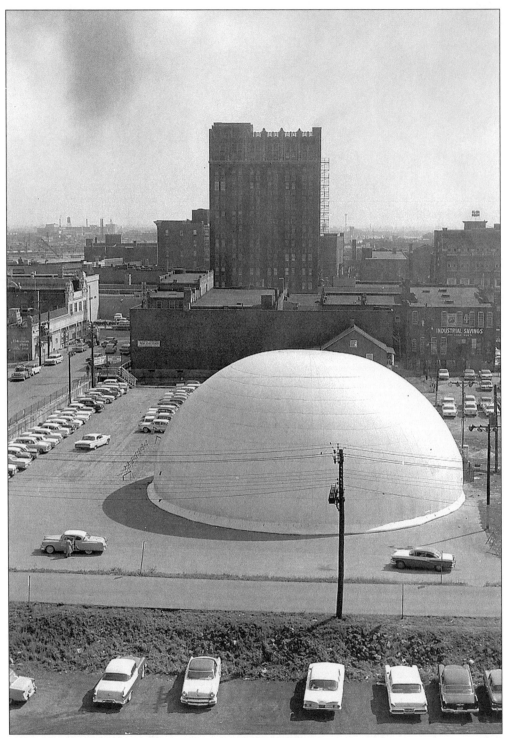

The university staged a dramatic planning seminar entitled EPEC, or Environmental Planning/Edwardsville Campus, on June 2, 1961. The participants gathered in a huge, white plastic bubble, 5 stories in height and 100 feet in diameter, kept rigid by electric fans.

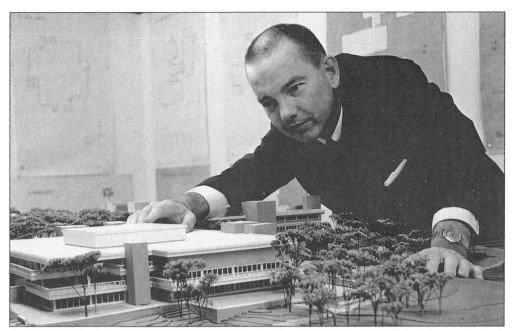

Robert Handy participated in the planning process for the University Center (student union) structure and served as the first director of that facility. Handy also coached a student baseball club that competed against area colleges during the spring of 1967.

John Randall served as the first architect employed by the Southwestern Illinois campus. He came to SIU in 1961 and served eight years as assistant, and then associate university architect. He administered the planning and construction staff at Edwardsville. Randall helped to acquire the Louis Sullivan architectural collection in 1965, and to save the Wainwright Building in St. Louis. He received an honorary doctorate in June 1982.

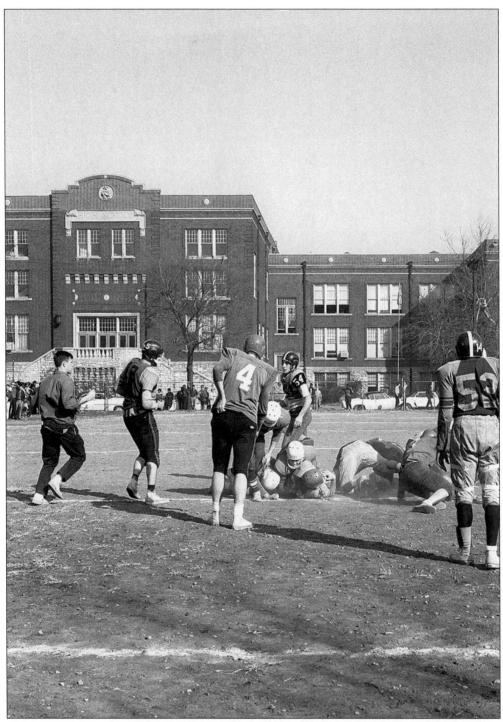

Even before the completion of the Edwardsville campus, students at the residence centers competed in intramural and (informally) in intercollegiate sports. In this image, East St. Louis students played an intramural, full-contact football game in pads and helmets. Howard Nesbitt and Norman Showers coached the residence center teams.

Eugene Redmond participated as a student leader at an early orientation session. Redmond served as associate editor of the *Alestle* student newspaper for the 1962–1963 school year and as editor, 1963–1964. After graduating in 1964, he worked as a reporter, attended Washington University (and obtained an M.A. in 1968), and taught at California State University. Redmond returned to Edwardsville in 1990 as a professor of English.

Although all residence center students commuted, many of them participated in a variety of campus activities such as freshman orientation.

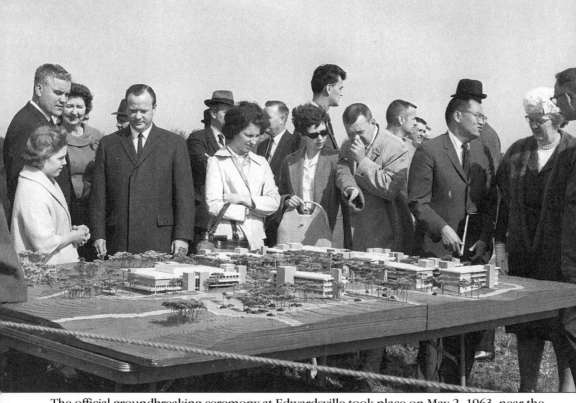

The official groundbreaking ceremony at Edwardsville took place on May 2, 1963, near the site of what had been the Freund house and what would become the center of campus. The groundbreaking activity featured a scale model of the first six proposed buildings.

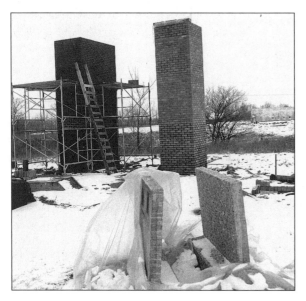

These brick towers were erected to test potential building materials. The metal structure visible in the background of this image, the Quonset Hut, became the home of the Student Experimental Theater Organization.

Bricklayers found need of their services at the new campus.

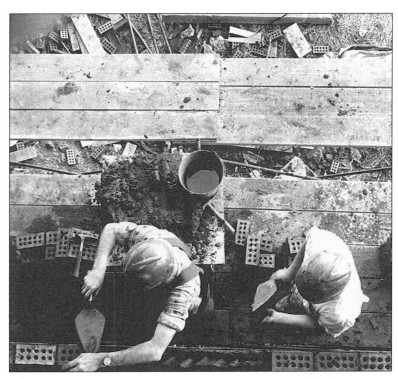

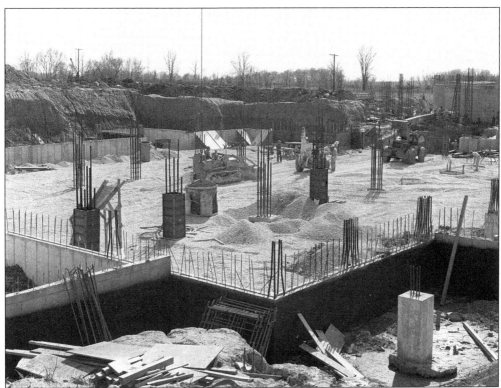

Construction began in the late spring and summer of 1963.

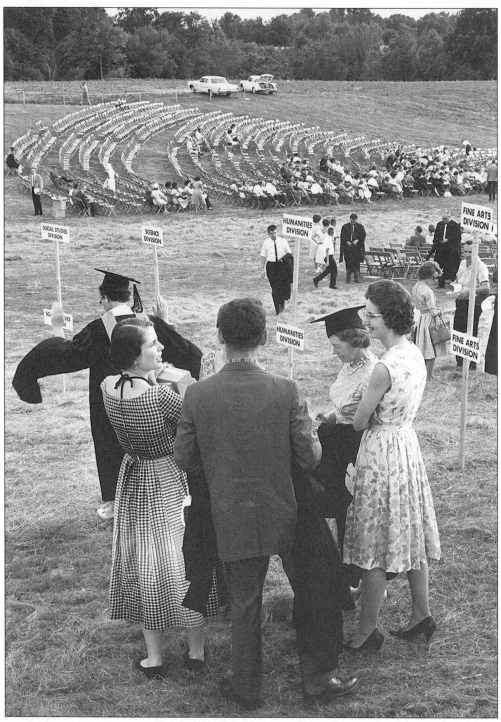

Beginning with the ceremony of June 14, 1963, the university began to stage commencement at the natural amphitheater on the northern part of campus, just west of Lewis Road and south of the intersection with Poag Road. Subsequently, in 1969, this amphitheater became the site of the Mississippi River Festival.

The Committee on Graduation Arrangements for the 1963 commencement included Carl Alford, Jerome Birdman, Gordon Bliss, H. Bruce Brubaker, Charles Butler, Clifton Cornwell, Loren Jung, Caswell Peebles, John Randall, John Schnabel, Mark Tucker, and William Going. President Delyte Morris conferred the degrees and certificates.

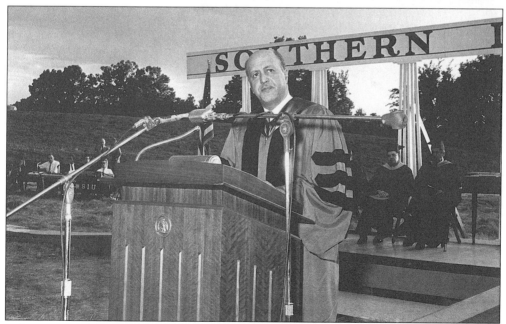

Robert Weaver, administrator of the Federal Housing and Finance Agency, served as commencement speaker and became the first recipient of an honorary degree from Edwardsville on June 14, 1963.

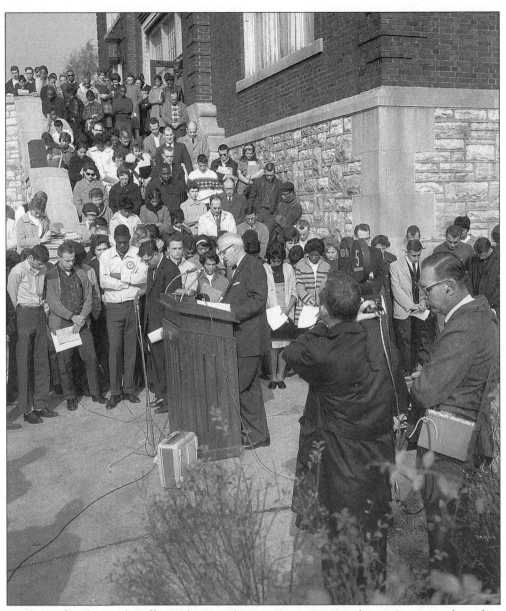

Students, faculty, and staff members at the East St. Louis Residence Center gathered to mourn the loss of President John Kennedy in November 1963.

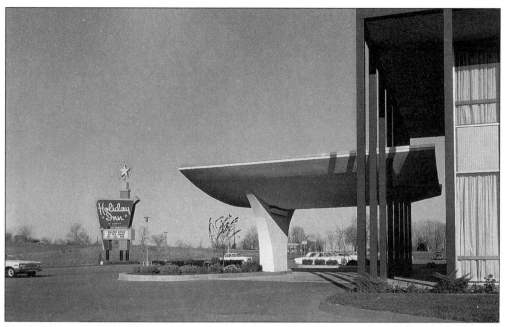

The Edwardsville Holiday Inn motel, located on Bypass 66 on the bluffs, served as the location for many early university gatherings.

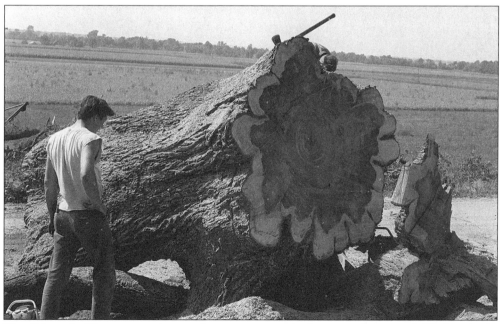

The Edwardsville campus boasted a monumental elm tree that stood 77 feet high, measured more than 6 feet in diameter, and had a spread of 125 feet. The magnificent tree fell victim to dutch elm disease and had to be removed on September 17, 1963.

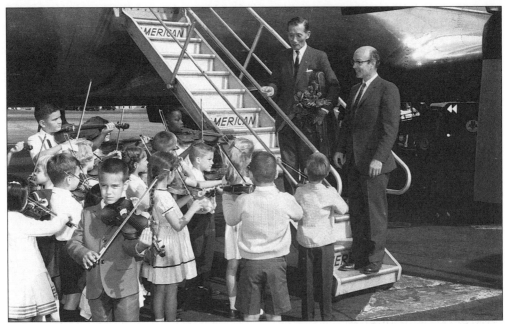

Music faculty member John Kendall (right) greeted Shinichi Suzuki, Japanese string teacher and founder of an instructional movement based upon early childhood music appreciation and tonal perfection of students. Kendall and his wife, Catherine, also pioneered the Watershed Nature Center in Edwardsville. Some of Kendall's young students joined in welcoming Suzuki at the airport.

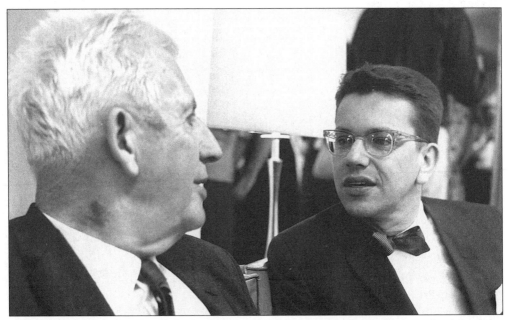

U.S. Senator Paul Douglas (left) and Illinois legislator Paul Simon frequently visited the Southwestern campus. Simon, a newspaper publisher, played a key role in the decision to name the new Edwardsville library in honor of the martyred Alton, Illinois, editor and abolitionist Elijah P. Lovejoy.

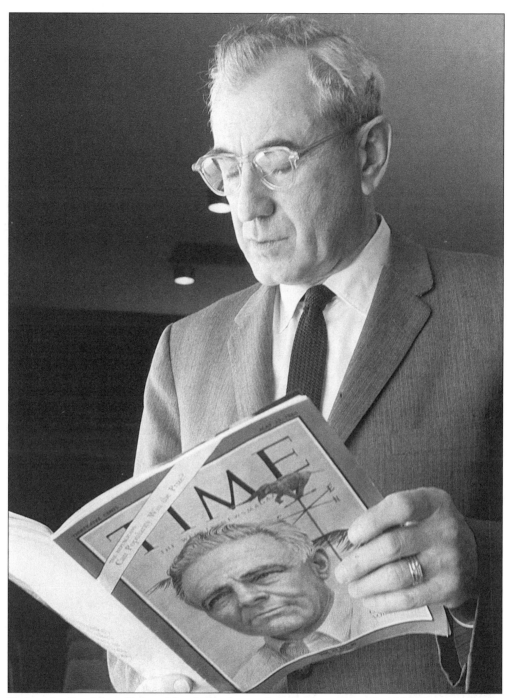

University President Delyte Morris is pictured studying a May 15, 1964 *Time* magazine article devoted to the rapid growth of the university. Morris realized that the creation of a second SIU campus in populous southwestern Illinois would better enable him to continue the development of SIU Carbondale as a major university with graduate and professional schools in the face of determined opposition from the University of Illinois and its supporters.

Construction of the first general classroom building and the library began in the late spring and early summer of 1963. In this image of the library as seen from the south, the large trees and white fence that had surrounded the Freund house are visible.

During the winter of 1964–1965, workers constructed the campus water tower. The Board of Trustees, on May 26, 1967, named the nearby utilities reservoir or lake that had been created to provide water for the heating and cooling plant after the new water tower—Tower Lake.

Two

THE EDWARDSVILLE CAMPUS

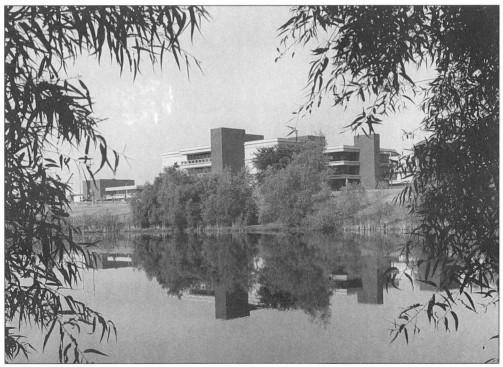

The water provided a reflection of the Peck Building as viewed from the northeast in the spring of 1967.

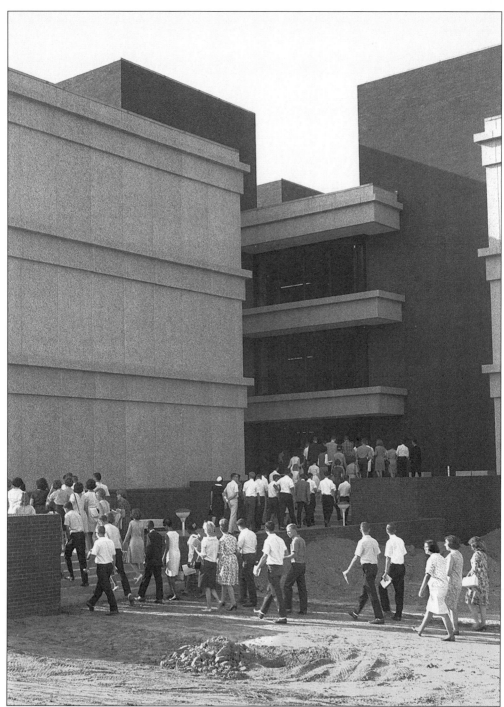

On the eve of the opening of the Edwardsville campus, the university scheduled tours of the first two buildings to become operational, the Peck Building, pictured here, and Lovejoy Library. The trustees named the general classroom building in honor of southwestern Illinois pioneer John Mason Peck, who had founded the Rock Spring Seminary in neighboring St. Clair County, the predecessor of Shurtleff College.

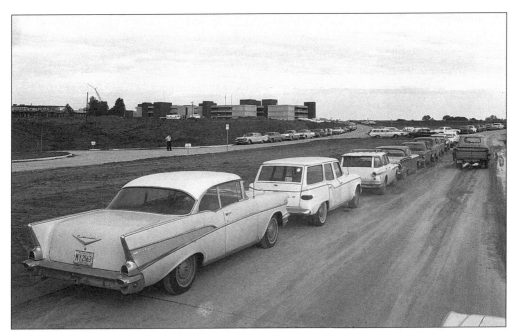

With the parking lots incomplete, students parked wherever they could, usually on the side of the road, and walked to class on opening day, September 23, 1965. The original master plan located all parking areas at a distance in order to preserve the natural beauty of the campus core.

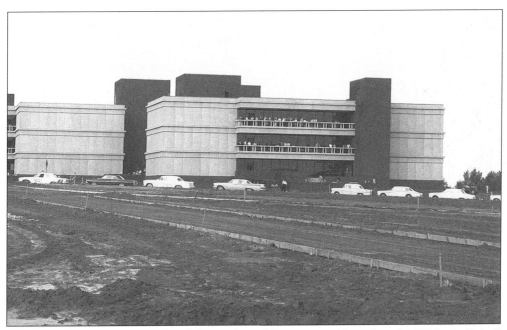

In this view of the east façade of the Peck Building, it is evident that the "Hairpin Drive" and the sidewalks have not been paved, and that the grounds have not been planted as yet.

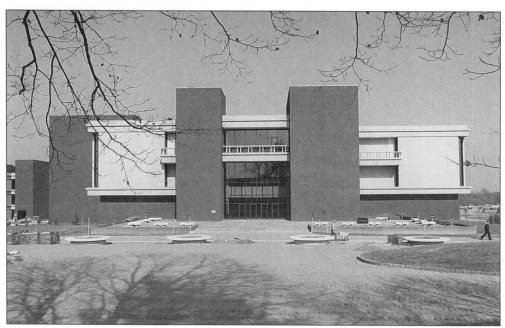

The south façade of Lovejoy Library is pictured as it appeared when the campus opened in 1965.

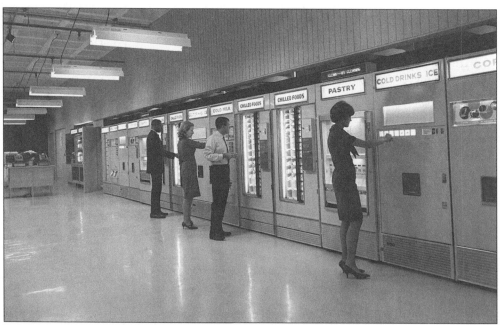

Prior to the opening of the University Center, students obtained food and dined in the basement of Lovejoy Library. Coin-operated machines provided food and drink for the weary scholar. Food could be heated in microwave ovens.

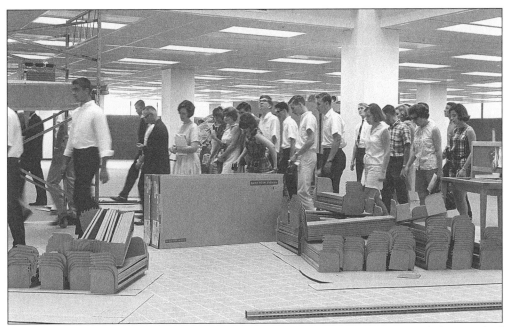

Many shelving units remained unassembled and much furniture remained unpacked when Lovejoy Library opened. The beautiful, open lightwell in the center of the library conveyed sound effectively and disruptively, just as the library staff had warned.

John Abbott, (left) founding director of Lovejoy Library, and Stanley Kimball, Historical Studies professor, examined the "Mormons in Illinois" microfilm collection assembled by the latter. Both men served the university with distinction over four decades.

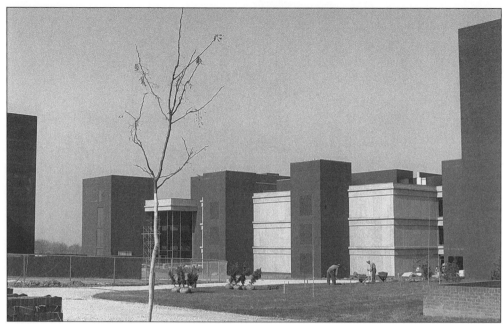

The Science Building, third of the original structures, began operation on September 21, 1966, for the second year of classes on the new campus. The formal dedication of the Science Building took place on May 26, 1967.

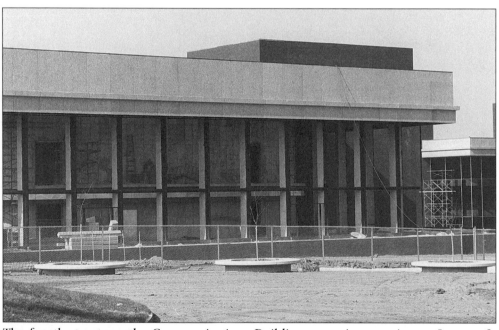

The fourth structure, the Communications Building, went into service on January 3, 1967. It housed classrooms, a theater, music rehearsal rooms, and broadcast facilities.

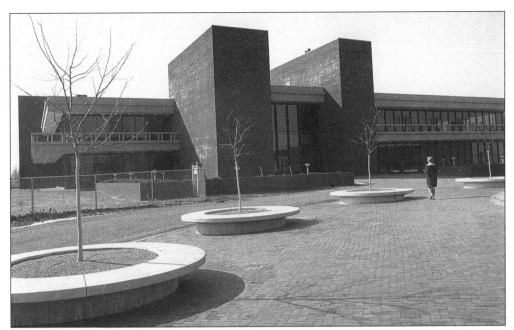

Dedication of the University Center, the "campus living room," occurred on March 3, 1967. Like its four neighbors, the two-story building featured plum-colored brick, pre-cast quartz aggregate concrete panels, and tinted glass. *Institutions* magazine, a professional journal for the food services and lodging industry, presented its 1968 total design award to the University Center.

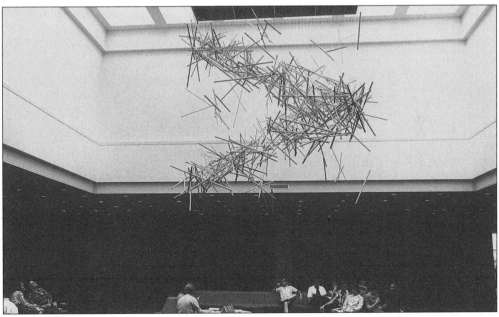

The mobile known as the "Plumbob," made up of 480 wooden dowels of varying diameter and length, floated above the Goshen Lounge area in the University Center. The Kate Maremont Foundation donated this artwork, designed by Yasuhide Kobashe of Kyoto, Japan.

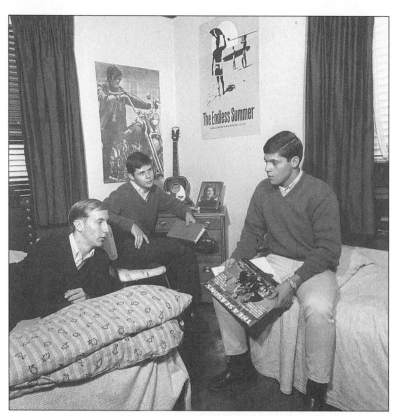

While most students commuted to campus from their family homes, some found apartments in nearby communities. The décor in this student apartment, *c.* October 1967, featured an "Endless Summer" poster, a Peter Fonda motorcycle poster, a guitar, and a record album by the Four Seasons.

In the center of the quadrangle formed by the original campus structures sat the Rock. Donated by a supply company as a sample of the quartz aggregate used on the buildings, the Rock originally stood knee high. The quadrangle was first named in honor of Delyte Morris, and later, William Stratton.

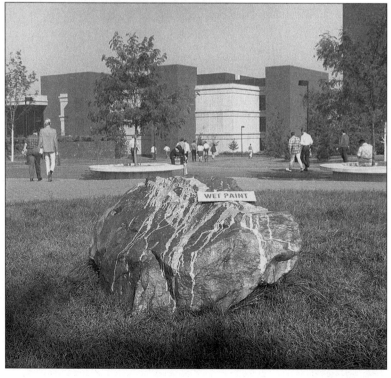

38

The Ranger Coffee House food service area of the new University Center contained a "frustration table." It was intended that students would carve their initials in the "frustration table" top and, at the end of each year, the top would be branded with a calendar year date and hung on the wall.

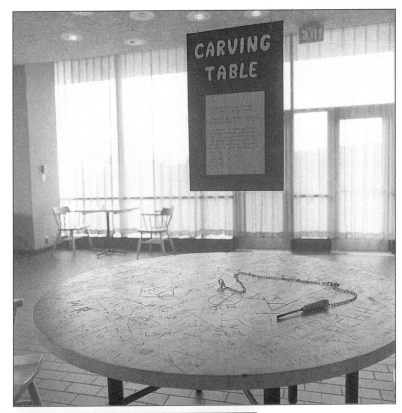

In succeeding years, the Ranger Coffee House became reincarnated as the Cougar Coffee House, the Sub-Meridian Dock, the Dock, the Cougar Den, and eventually as a pizza fast food area.

The trustees designated the new main entrance road from Illinois 157 as "University Drive" on December 11, 1965. Workers installed a new campus sign at that intersection in May 1966.

Consulting engineers recommended the creation of a manmade lake or reservoir rather than cooling towers to serve the new heating and refrigeration plant. The Board of Trustees named the artificial lake after the campus water tower. At a May 27, 1967 ceremony, President Delyte Morris dedicated the recreational lake and a fleet of twelve canoes, four rowboats, and two sailboats.

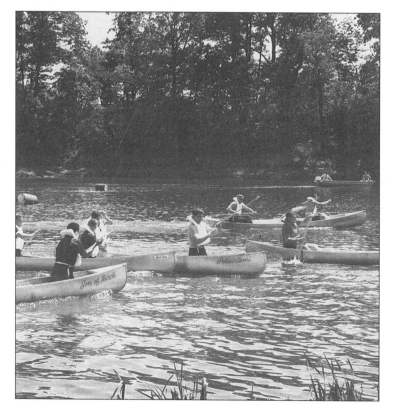

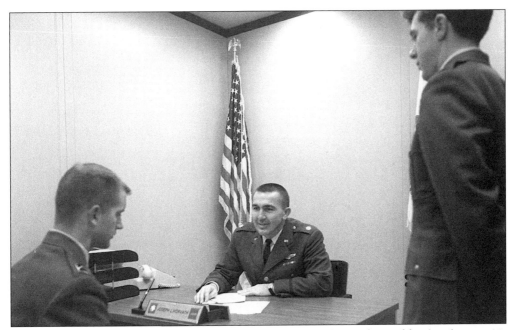

An Air Force ROTC program began operation during the 1965–1966 school year. Air Force Major Joseph Horvath commanded the program when Raymond Franks Jr. of St. Louis and Michael Blackburn of Caseyville became the first Edwardsville cadets to receive their commissions on June 9, 1967.

The university transferred its nursing program to the Southwestern campus effective spring quarter (March 29) 1964, under the direction of Margaret Shay. Dean Lucille McClelland, appointed in May 1968, became the first African-American dean at Edwardsville. Nursing faculty members moved first from Carbondale to East St. Louis. In November 1968, the faculty moved to the second floor of the University Center and in 1977 to Building III.

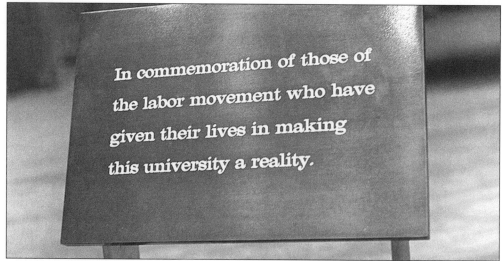

In commemoration of those of the labor movement who have given their lives in making this university a reality.

During early October 1967, the university staged a three-day Labor Institute for union and government officials. Teamster leader Harold Gibbons spoke about union leadership and the larger community. In memory of five workers who died in accidents during the construction of the campus, participants placed a commemorative plaque beneath the national flagpole on October 7, 1967.

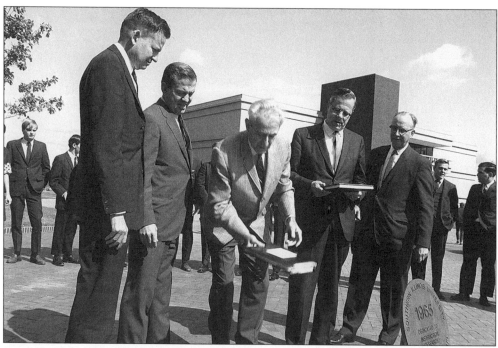

A year of formal dedication activities began on May 13, 1966, when President Delyte Morris addressed a crowd in Lovejoy Library. The concluding event in the process took place with the burying of a time capsule on the mall on October 10, 1967. Participants in the latter event included, from left to right: Vice President Robert MacVicar, Vice President John Rendleman, Morris, Vice President Ralph Ruffner, and veteran administrator William Tudor.

Spring Festival 1968 included an Internationale Day that offered colorful exhibits and students dancing in the garb of their homelands.

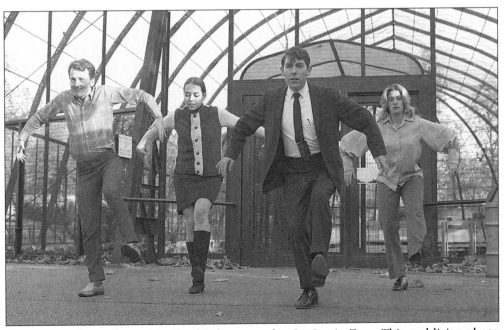

Dancers performed outside the birdcage at the St. Louis Zoo. This publicity photo promoted a student production of "The Birds."

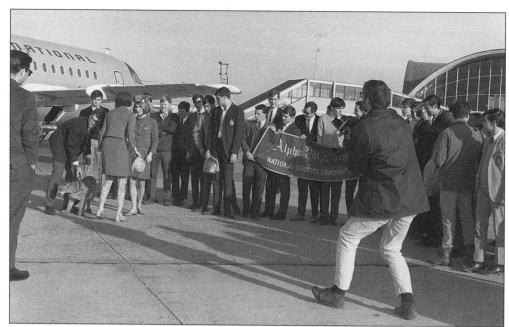

An Edwardsville student referendum during fall registration in 1967 selected the mascot symbol "Cougar," and President Delyte Morris approved the symbol in October. Warren Stookey, SIUE Alumni Association director, and junior Walter Parrill of the Alpha Phi Omega service fraternity, flew to Houston to pick up a live female cougar named Danielle and returned with the new mascot on February 19, 1968.

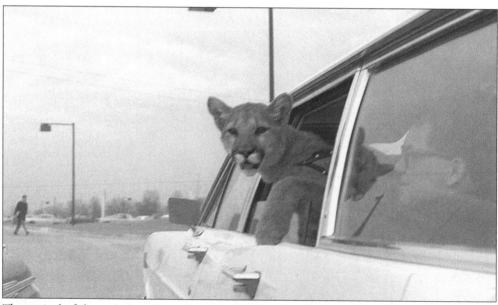

The arrival of the cougar on campus turned a few heads. In a subsequent contest during Springfest, Mary Ann Kucinick suggested the name "Chimega" for the new mascot. A student volunteer organization called the Cougar Guard began caring for Chimega in January 1969. Chimega moved into her permanent home south of the University Center, a cage topped with a geodesic dome designed by Buckminster Fuller, in June 1970.

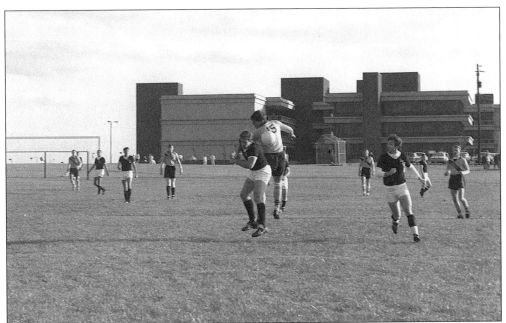

Bob Guelker came to Edwardsville from St. Louis University to direct the intramural sports program in September 1967, and officially became the first soccer coach in October. The Cougars won the first official university intercollegiate victory at Blackburn College on October 11. In the first home game (October 25), played on a field north of the Peck Building, the Harris Teachers College team defeated the Cougars.

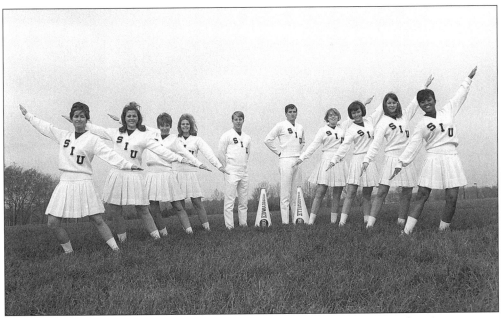

In the first Homecoming soccer game, held on November 3, 1967, the Cougars defeated the University of Missouri at St. Louis, 6–0. This initial soccer home victory, on the field behind the Peck Building, marked the first public appearance by the new cheerleading squad.

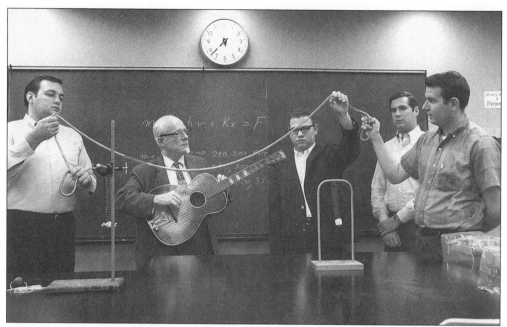

In a January 1968 physics class, Professor William Shaw used his guitar to discuss music and acoustics. Shaw joined the East St. Louis Residence Center in 1959 and, up until his retirement in 1973, fascinated students by using common items, including his pet dog, to demonstrate principles of physics. After his death in 1977, the university renamed the campus astronomy viewing site as the William C. Shaw Skylab.

Actress Thelma "Butterfly" McQueen (left) attended courses while assisting her friend and dance mentor, Katherine Dunham. A dancer and choreographer of international reputation, Dunham maintained an affiliation with the university from 1967 through 1982, and founded the Performing Arts Training Center in East St. Louis. In recognition, the university renamed the Communications Building as Katherine Dunham Hall in 1999.

46

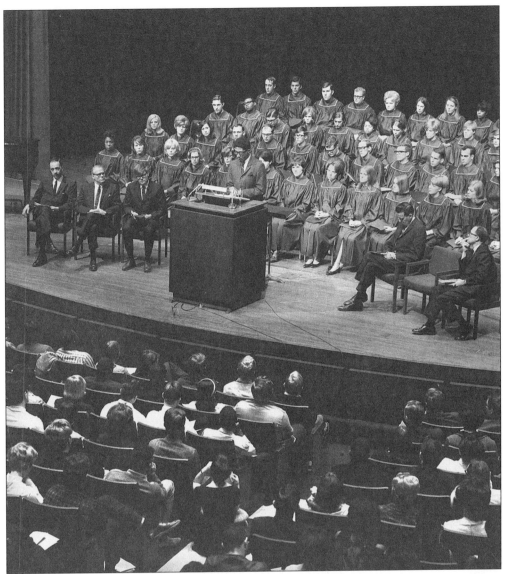

Members of the university community gathered in the Communications Building Theater on April 5, 1968, to pay tribute to the memory of the martyred Dr. Martin Luther King Jr. January 15, the civil rights leader's birthday, became an official part of the university calendar in 1971. Major annual observances of the anniversary of King's birth began on January 14, 1983, and became a university tradition.

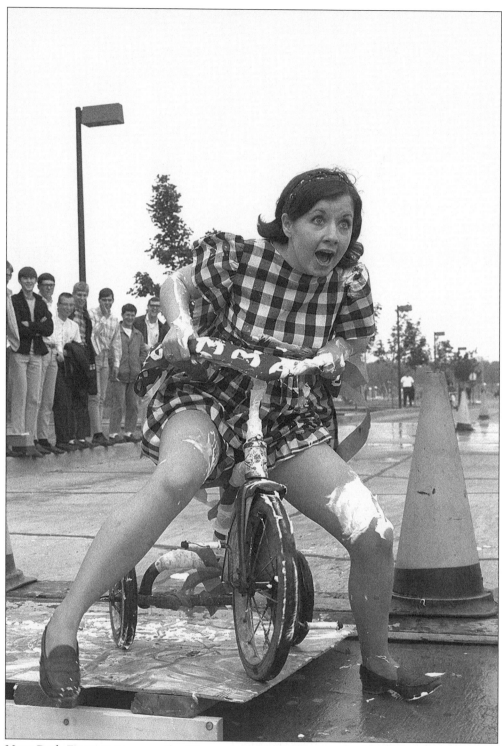

Mary Beth Fitzmaurice won the Women's Tricycle Event at Springfest in May 1968.

Roy Lee joined the Edwardsville faculty in September 1967. The inaugural Cougar baseball team lost their opening contest at McKendree College on April 3, 1968. The Cougars posted their first victory against Harris Teachers College in their first home game, played on April 10, 1968, on a diamond northwest of the Science Building.

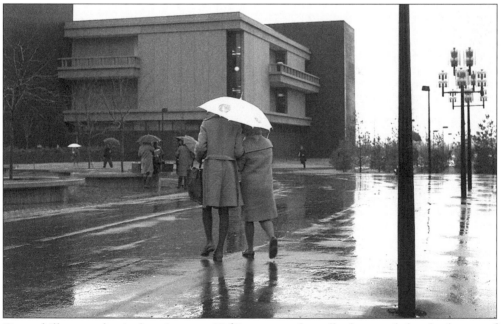

On a chilly, wet day in late January 1969, two coeds walked toward the dry haven of Lovejoy Library.

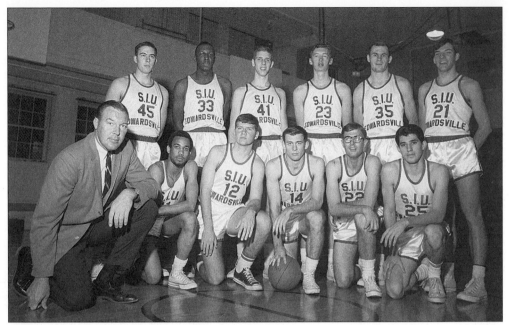

Harry Gallatin (left), former NBA star, became the founding basketball coach in November 1967. His team practiced in the Alton gym and played its home games at Edwardsville High School. After losing their first two games on November 22 and 24, the Cougar cagers achieved their initial intercollegiate victory in their opening home contest against Sanford Brown of St. Louis on December 6, 1967.

Junior guard Tom Dahncke scored 32 points in the 95–82 defeat of Sanford Brown. In March 1970, Harry Gallatin retired as basketball coach to concentrate on his duties as athletic director and golf coach. In three seasons, 1967–1970, his basketball teams produced a record of 19 wins and 31 losses. Jim Dudley succeeded Gallatin from 1970 through 1981, and achieved a 146–143 record over 11 seasons.

Tom Pugliese coached the basketball Cougars from 1981 through 1983. The university did not field a team during 1983–1984. Larry Graham took over as coach for the 1984–1985 season, as the Cougars finally abandoned the EHS gym and moved on campus into the new Vadalabene Center. Graham remained until 1992, and won 147 games against 84 losses, before Jack Margenthaler assumed the coaching job.

Mississippi River Festival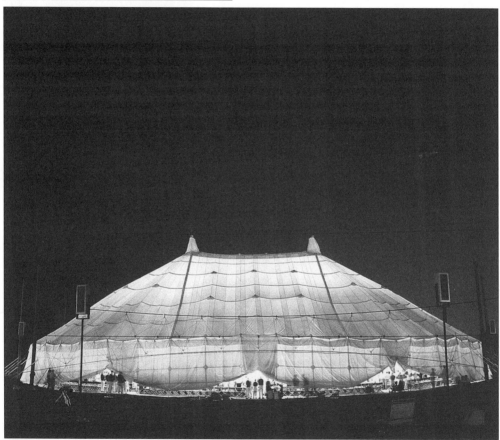

On March 17, 1969, President Delyte Morris and the St. Louis Symphony announced plans for a summer music festival in Edwardsville, the Mississippi River Festival (MRF). In eight weeks, university workers led by Gene Cobbel, Al Felchlia, and William Gentry transformed the natural amphitheater site. Graphics designer A.B. Mifflin created a striking logo that combined the festival name with representations of the moon and the Mississippi River.

The U.S. Tent and Awning Company of Sarasota, Florida, created the original MRF tent, a structure 140 feet wide, 170 feet in length, and 65 feet high at the masts. Veteran tentmaster Skip Manley initially served as a consultant to the manufacturer and subsequently became the man in charge of the tent.

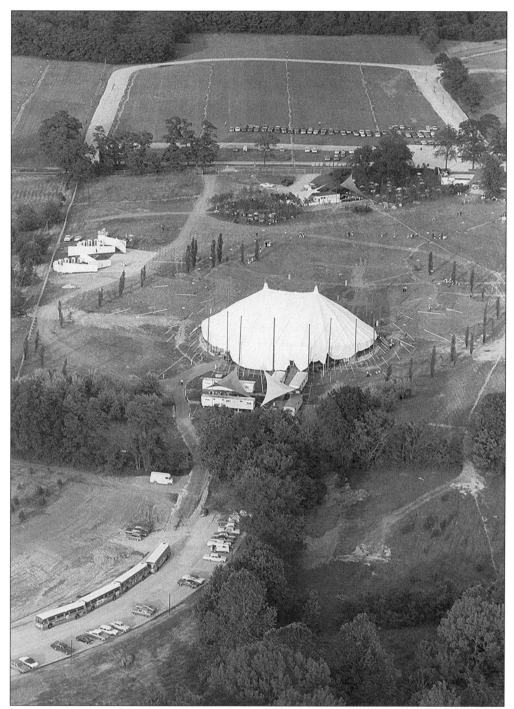

A "Pique-nique" social event on the central mall, attended by many St. Louisans who paid $7.50 to participate, preceded the first MRF concert on the evening of June 20. The MRF provided summer employment for symphony performers and helped publicize the university to people living west of the Mississippi River. The 1969 MRF schedule included 18 Friday, Saturday, and Sunday night St. Louis Symphony concerts.

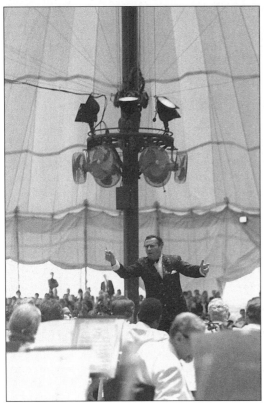

The opening night for MRF, Friday, June 20, 1969, starred music director Walter Susskind and the St. Louis Symphony in a program that included works by Purcell, Schubert, and Beethoven. Susskind appeared as featured pianist as well as conductor during the season. Dodie Ladd, a freshman usher at the MRF, won momentary fame as the bell-tree ringer who called symphony audiences back to their seats after intermission.

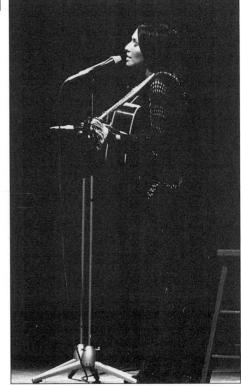

Buffy Sainte-Marie, Cree Indian singer, opened the MRF pop/rock/folk season on Monday, June 23, 1969. Other performers included the following: the Modern Jazz Quartet (June 24); the Butterfield Blues Band (June 26); the King Family (June 30); Janis Joplin (July 1); Joni Mitchell and Arlo Guthrie (July 7); Iron Butterfly (July 10); The Band, with a surprise encore by Bob Dylan (July 14); Ian & Sylvia (July 17); the New Christy Minstrels (July 21); Richie Havens (July 22); and Joan Baez (July 23).

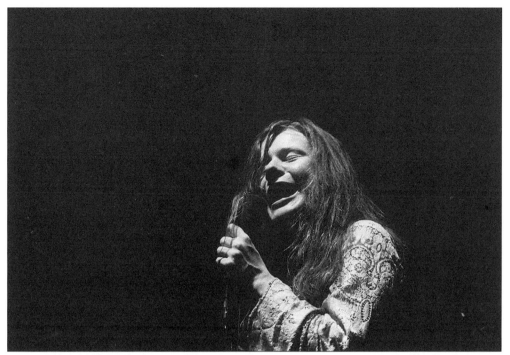

Janis Joplin appeared on July 1, 1969, before an MRF crowd estimated at 10,000–12,000 people, the largest attendance to date. After Joplin returned to the stage to render an encore performance of "Piece of My Heart," hundreds of listeners crowded the stage to touch the hands of the great blues vocalist.

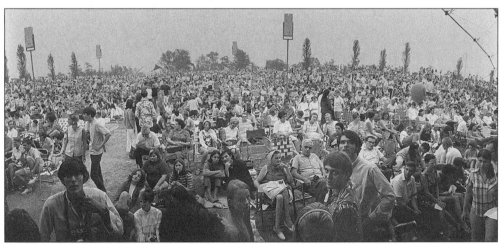

An estimated crowd of 15,000 persons attended the Joan Baez concert on July 23, 1969. Perhaps an even larger audience arrived for the Iron Butterfly appearance on July 10, when muddy conditions forced officials to close the parking lot, and thereby created massive traffic problems. In years to come, tens of thousands of people would claim to have heard Bob Dylan perform unexpectedly with The Band at the MRF, although only 3,000–4,000 fans had actually been in attendance that night.

Entering students attended orientation in the University Center's ballroom in September 1968.

Christine Pashoff cut the ribbon that marked the opening of the University Center's second floor on September 27, 1968. From left to right are: Center Director Robert Handy, Chancellor John Rendleman, and Center Board President Milton Wharton, who all took part in the ceremony. New facilities included the University Club restaurant, offices for nursing and business faculty members, and the completed Meridian Ballroom, located upon the 90th meridian.

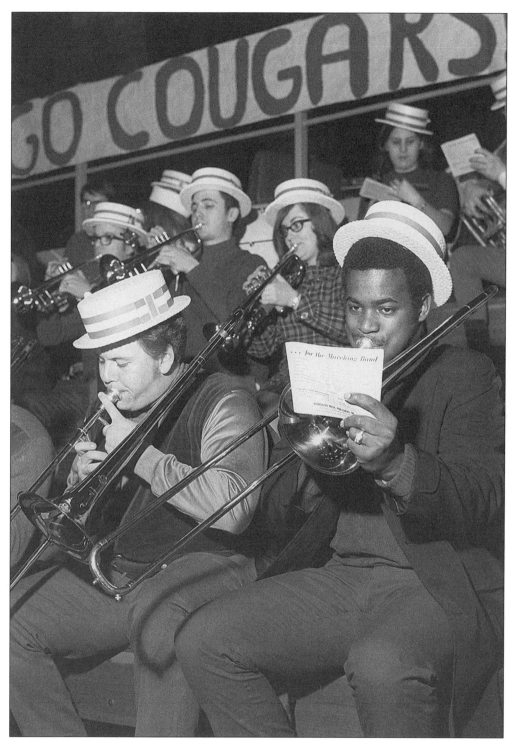

The Pep Band performed at a home basketball game between the Rivermen of the University of Missouri at St. Louis and the Cougars on January 6, 1969. Fans had adequate time to listen to the Pep Band that night, as UMSL crushed the Cougars, 103–58.

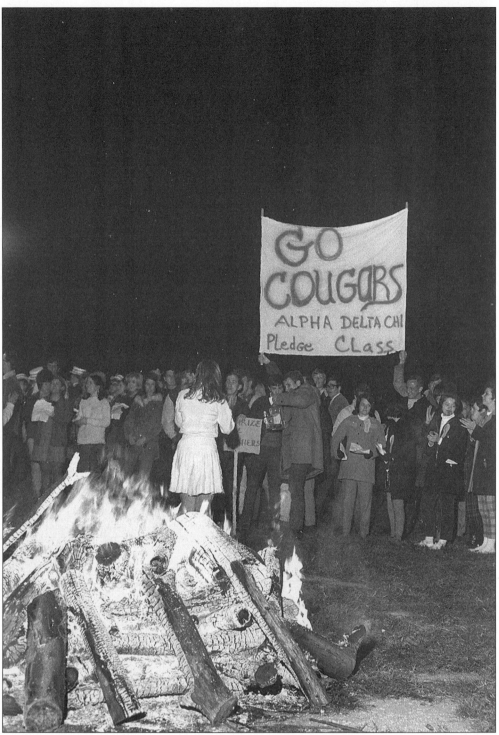

Edwardsville students staged a homecoming pep rally, complete with bonfire, on the evening of Friday, October 25, 1968. Marilyn Hlavsa reigned as homecoming queen, attended by Donna Dustman, Ginger Dustman, and Christine Pashoff.

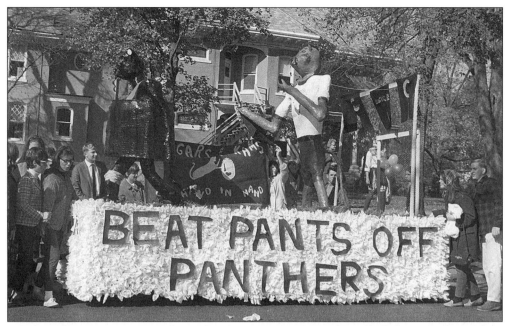

On Saturday morning, October 26, a homecoming parade rolled through downtown Edwardsville. The parade included floats from the Alpha Phi Omega, Delta Kappa Tau, and Kappa Alpha Mu service fraternities. After a soccer game against the Greenville College Panthers, the homecoming dance took place in the newly-completed Meridian Ballroom of the University Center.

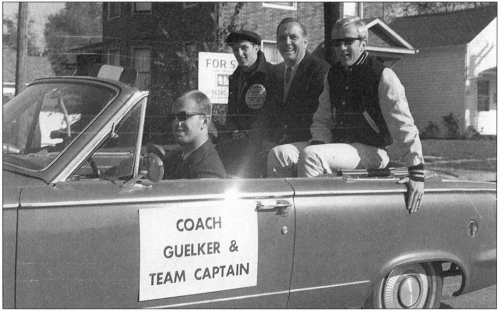

Soccer Coach Bob Guelker took part in the homecoming parade. In the Saturday afternoon game, the Cougars set a new scoring record by smashing Greenville College, 10–0. On Sunday evening, October 27, singer John Davidson entertained at the homecoming stage show in the Meridian Ballroom.

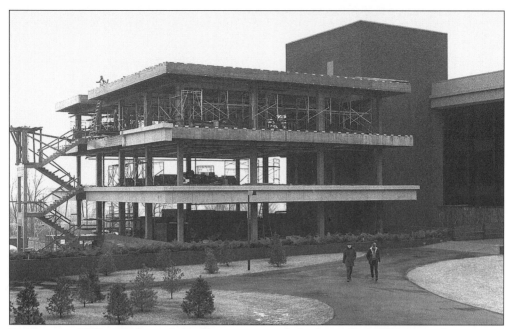

By January 1969, much work had been accomplished on the addition to the Science Building. The new Science Building office wing extended southward toward the Communications Building. Construction of a sixth major structure, the new General Office Building, also neared completion at a site east of the University Center and across from the Peck Building.

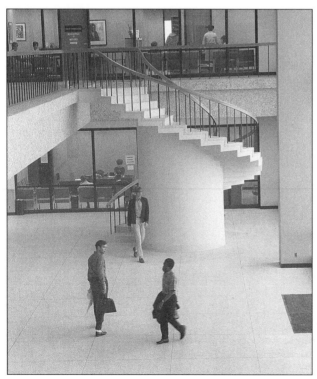

During the middle of February 1969, employees of the Registrar's Office became the first occupants of the new General Office Building. University News Services staff members joined them in the new structure on April 8, 1969.

The two-lane south leg of University Drive opened on December 5, 1966. A second two-lane segment leading to the south campus entrance began operation on September 24, 1968. This new sign greeted visitors entering campus from the south in April 1969.

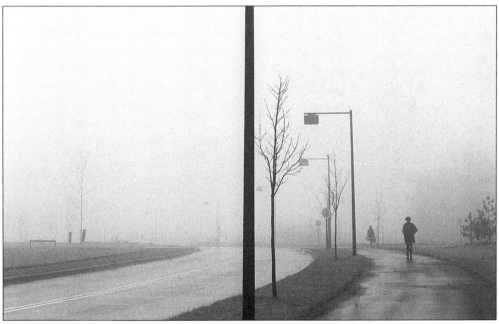

An uncommon weather condition, fog, embraced the Edwardsville campus on January 17, 1969, adding a sense of mystery to everyday comings and goings.

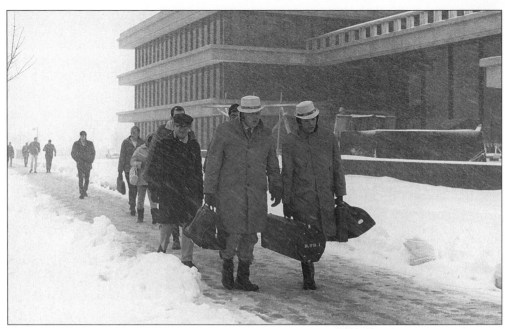

As is sometimes the case, late February 1969 brought an unwelcome return of winter weather to southwestern Illinois.

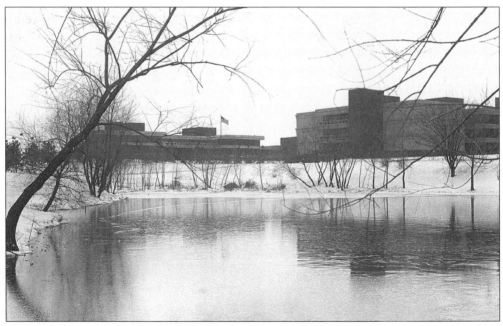

Photographer Charlie Cox captured a Christmas-time view of the General Office Building and the Peck Building from across the lake in late December 1969.

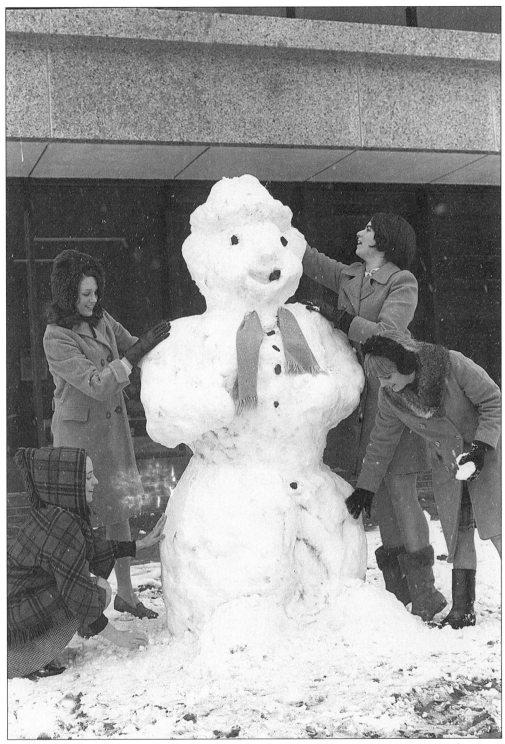

Students built a large snowman outside the Peck Building in late February 1969.

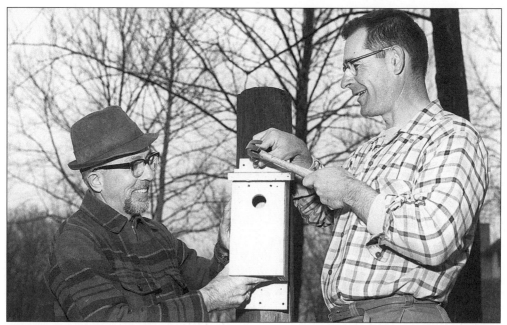

Audubon Society members John McCall (left), a psychology professor, and John Arcynski hung birdhouses around campus in March 1969. McCall served as a faculty member from 1965 until his retirement in 1989. On January 16, 1974, McCall gave the opening address in the inaugural University Seminar at Edwardsville series of interdisciplinary presentations.

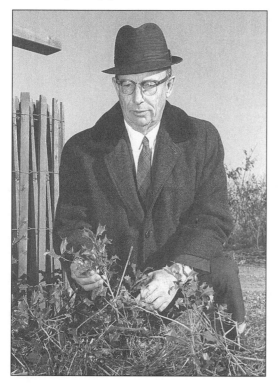

Beginning in January 1962, Edward Hume served as horticulturist and landscape gardener for the Edwardsville campus. Hume and his associates planted over 150,000 evergreen and 30,000 hardwood seedling trees in just one year. They also planted sod, sowed grass seed, and installed bushes, shrubs, and ground covers to foster soil conservation and to transform dozens of parcels of property into a carefully planned physical environment.

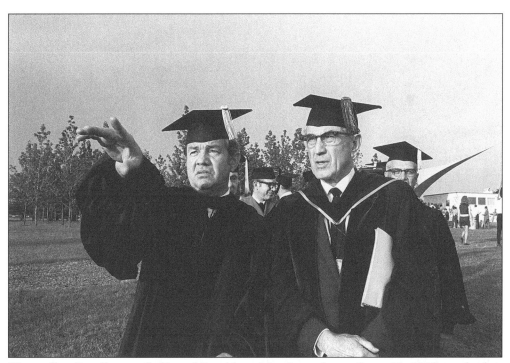

Chancellor Rendleman (left) and President Morris spoke on June 13, 1970, at the last commencement presided over by Morris. Disenchanted over the Stone House at SIUC and student violence that led to the closing of the Carbondale campus on May 15, the Board of Trustees forced Morris to retire on June 19 and eliminated his position on August 3. SIUE later honored Morris with a memorial bike path (October 6, 1974) and a bust (April 9, 1976), and named the quadrangle for him on April 14, 1979.

R. Buckminster Fuller, noted theorist, designer, mathematician, and inventor, served as commencement speaker on June 13, 1970. Fuller, the creator of the geodesic dome, joined the Carbondale faculty in 1959 and moved to SIUE in July 1972. Fuller retired as university professor emeritus in 1975 and received an honorary doctorate from Edwardsville on June 8, 1979.

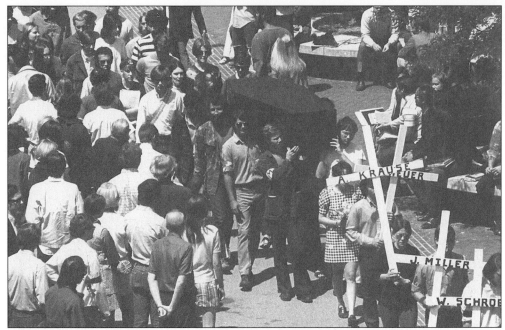

Ohio National Guardsmen shot and killed four anti-Vietnam War demonstrators at Kent State University on May 4, 1970. The murders of four civilians by members of the American military greatly stimulated antiwar activities on campuses throughout the nation. During a demonstration, SIUE students carried crosses and a casket to draw attention to the killings.

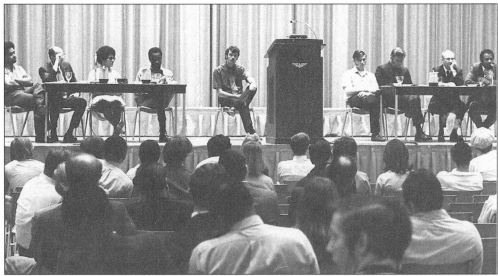

In response to Kent State and events in Carbondale, Chancellor Rendleman scheduled a series of convocations. On May 18, a "moratorium" on racism took place, followed on the next three days by convocations on violence, war, and solutions. As economic background to these tumultuous social events, Governor Richard Ogilvie ordered state-financed capital improvements frozen, and on May 7, Rendleman suspended faculty hiring and proposed an enrollment cap of 13,700.

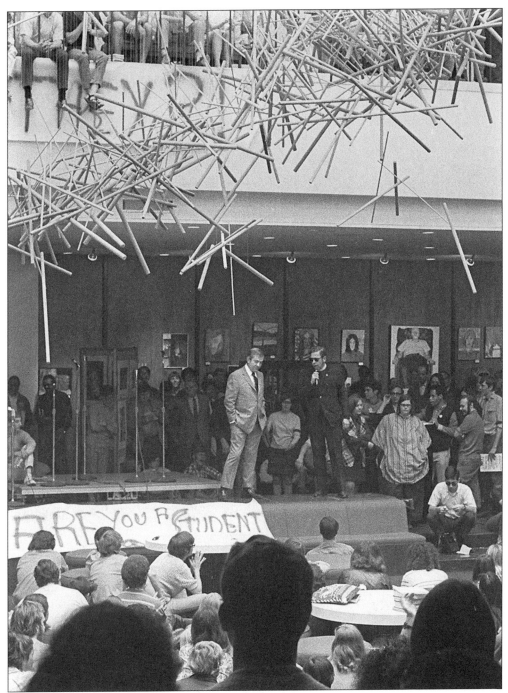

On May 5, 1970, Chancellor Rendleman held an open forum in the Goshen Lounge and responded to questions from students. Earlier in the day, Rendleman ordered the U.S. and Illinois flags removed in order to prevent any potential confrontation. Contemporaries believed that Rendleman's obvious willingness to engage in open dialogue, and his stated opposition to the Vietnam War, greatly helped to prevent violence at SIUE.

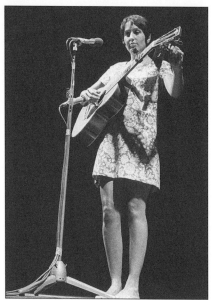

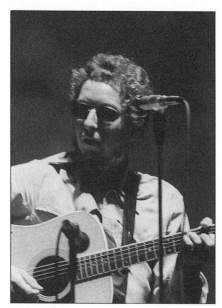

Pregnant singer Joan Baez performed at MRF on July 23, 1969, one week after her husband went to prison for resisting the draft. Baez had performed in conjunction with Martin Luther King Jr.'s "I Have A Dream" speech, so her MRF appearance personified the anti-war and civil rights movements. Afterwards, Walter Susskind expressed pleasure that 12,000 fans heard a "singer who has taste, talent, and can sing quietly."

The Band came to the MRF on July 14, 1969, four days after Iron Butterfly drew a huge crowd. The 4,000 fans in the audience were shocked when Bob Dylan, who had performed in concert only twice since an August 1966 motorcycle accident, and who had been traveling with his former backup group, unexpectedly joined his friends for a four-number encore.

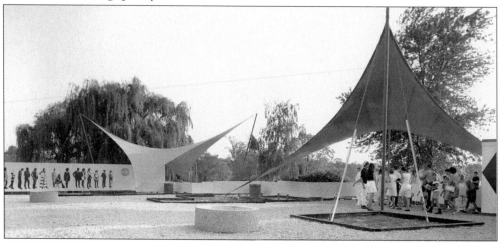

Prices for seats under the tent in 1969 included $5.50 for box seats, $4.50 for front-row seats, $3.50 for rear seats, and $2.50 for side rear seats. Lawn seats were $1.50 for adults and $1 for children.

Three
TIME OF CHANGE

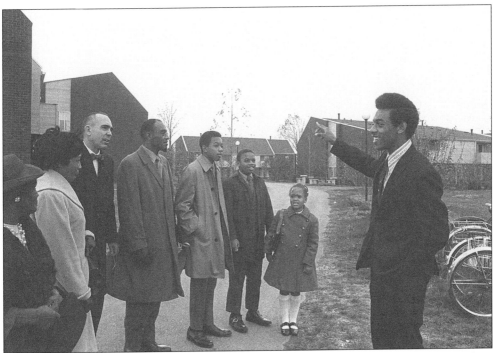

The north shore of Tower Lake became the location for the first on-campus student housing. As seen in this photo, dedication of the Tower Lake apartments—featuring 104 four-student units, plus 92 two-bedroom and 48 three-bedroom family apartments—took place on November 15, 1970.

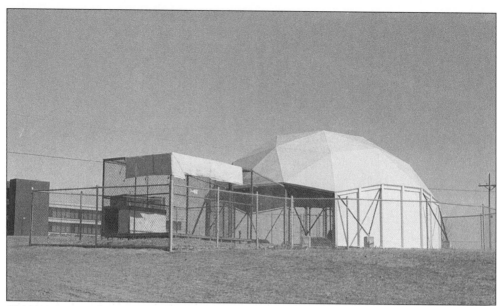

Chimega moved into her permanent home on the hillside south of the University Center in June 1970. The gentle mascot walked around campus twice daily in company with Cougar Guard attendants, made public appearances at sporting events and student activities, and participated in parades. Chimega appeared in a University Theater production of "Carnival" in 1971.

Gregg McGee of Granite City (the subject of this photo) succeeded Keith Knabe of O'Fallon as student manager of WSIE at the start of 1971. The university received Federal Communications Commission approval to construct the noncommercial FM radio station (88.7 megahertz) on January 29, 1969. Approval of the call letters WSIE came on April 21, 1969, and broadcasting began on September 4, 1970.

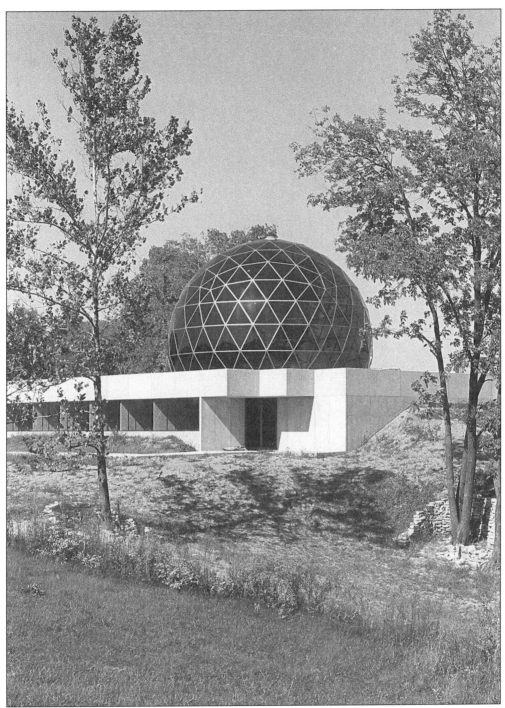

Dedication ceremonies for the privately-financed Religious Center took place October 18–24, 1971, highlighted by a Buckminster Fuller speech on October 22. Fuller designed the center and the geodesic dome, a globe with blue Plexiglas depicting the waters of the earth and clear Plexiglas representing the continents. Because the 90th meridian ran through the building, an inside observer could view Earth as it would appear from its axis.

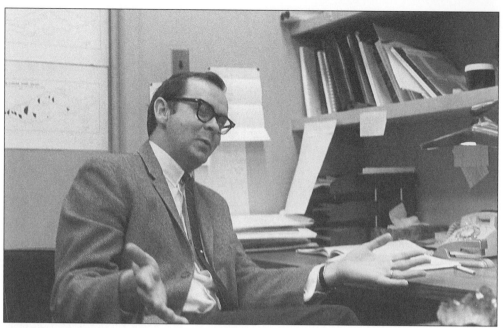

Ronald Yarbrough, earth sciences professor, received the first Great Teacher Award from the SIUE Alumni Association at Honors Day, May 17, 1970. Yarbrough, a graduate of the University of Tennessee at Knoxville, won the award for effectiveness as a classroom teacher.

Anthropologist Sidney Denny studied evidence from a 1971 summer dig on the bluffs near Alton. Denny and his students for many years carried out excavations and analyses of indigenous sites at and related to the great metropolitan complex of Cahokia.

Professor Dan Anderson, shown here in December 1971, joined the faculty in 1970. A ceramic sculptor, Anderson received a National Endowment for the Arts Fellowship in 1990. Anderson won the Paul Simon Outstanding Scholar Award in 1996.

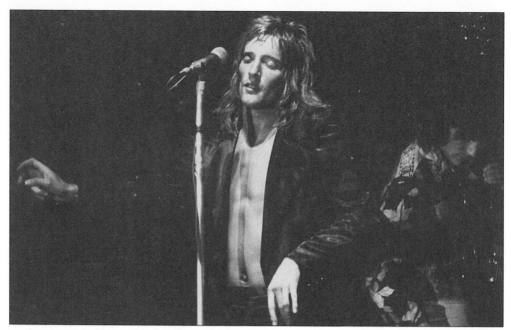

Rod Stewart & Faces shared the MRF bill with Ian Matthew and the Southern Comfort, another British group, on August 4, 1971. Stewart's band included Ron Wood from the Jeff Beck Group and former members of Small Faces.

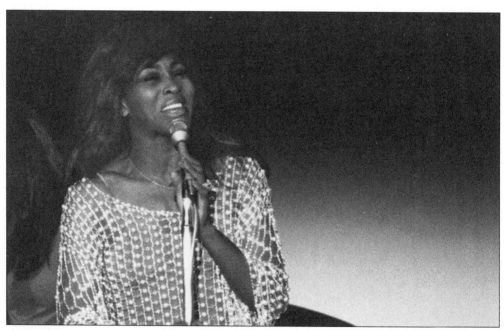

Ike and Tina Turner met in St. Louis in 1956, so their appearance at the MRF on July 30, 1971 qualified as a homecoming of sorts. Cool weather and a damp lawn failed to deter a crowd of 14,000 from attending.

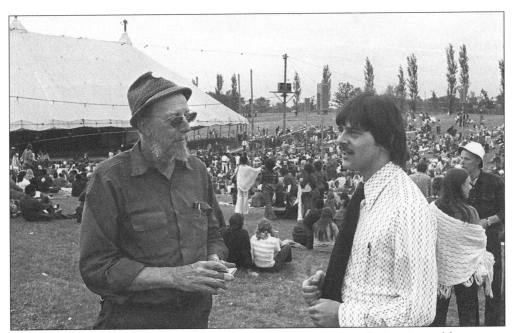

Lyle Ward (right), a graduate of SIUE, managed the MRF during its golden years. Contemporaries attributed much of its success to his hard work and good judgment. Tentmaster Skip Manley, seen here with Ward in May 1973, brought unique and invaluable circus experience to his mammoth task.

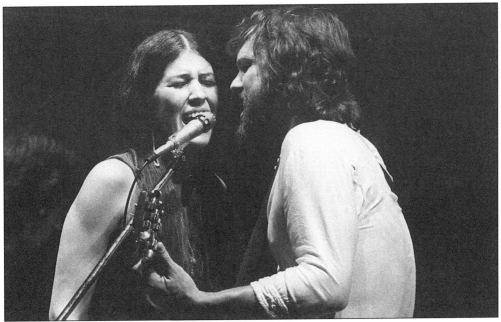

Kris Kristofferson and his wife, Rita Coolidge, entertained a crowd of six thousand at the MRF on July 11, 1972. Disappointed in the quality of his performance, Kristofferson apologized to the audience.

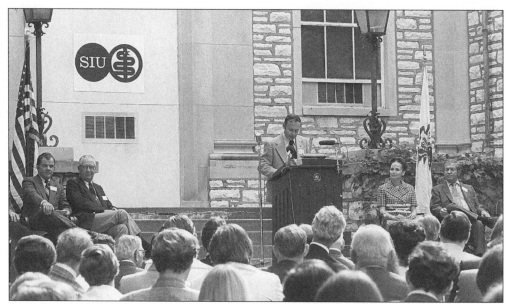

The Board of Trustees voted on April 18, 1969, to establish a School of Dental Medicine in Edwardsville, the first in Illinois outside the Chicago area. Classes began at the former Shurtleff College campus in Alton on September 5, 1972, even before the October 3 dedication ceremony shown here. The first dentists from the three-year program graduated in the Communications Building Theater on August 9, 1975. The school changed to a four-year curriculum in the fall of 1978.

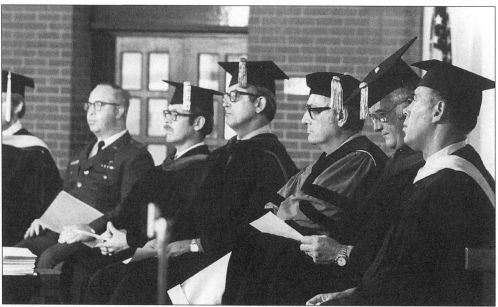

To serve the men and women of the Air Force Military Airlift Command (MAC), the university inaugurated an on-base graduate program in business administration. The program began in the fall of 1969, and began to produce graduates in late October 1971. President Rendleman gave the commencement address at nearby Scott Air Force Base in the June 26, 1973 ceremony pictured here.

The University Theater presented its first annual repertory theater season during the summer of 1972. The schedule included "Hotel Paradiso," "Luv," "Celebration," "Day of Absence," and "Happy Ending." The free repertory theater performances took place in the Communications Building Theater.

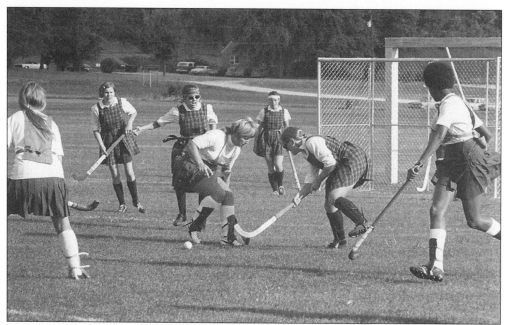

Intercollegiate sport competition for women began at Edwardsville on October 4, 1972. In a home game, Barbara Maue scored both goals as SIUE defeated Greenville College, 2–1. Rosemarie Archangel, women's athletic director, also served as the coach for field hockey.

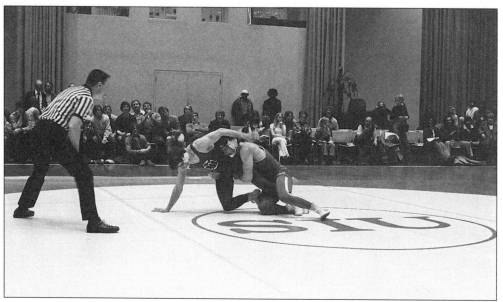

Larry Kristoff became the first varsity wrestling coach in September 1969. The team achieved its first victory by a 21–15 score in a January 1970 match at the University of Evansville and finished an abbreviated schedule with a 2–0–1 mark. Lacking a proper venue, the team competed for years in the University Center Meridian Ballroom. On February 25, 1984, the wrestling Cougars achieved their first NCAA Division II national championship.

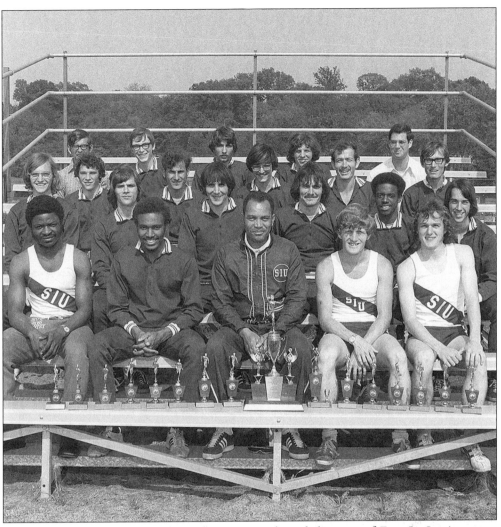

Jack Whitted, former coach at Rock Junior High and director of East St. Louis center intramurals, became the first track coach in September 1969. The Cougars began competition with a loss to Washington University on March 28, 1970. They started their home season on the Roxana High track with a victory (89–51) over Illinois College on April 6, 1970. From 1969 to 1978, Whitted's track teams (including the 1973 team seen here) posted a 63–20–1 record.

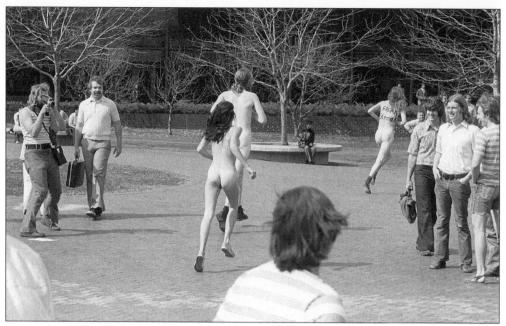

The national fad of streaking reached SIUE in the spring of 1974. In this photo, female and male streakers raced across the quadrangle on March 8, 1974. A small crowd gathered to enjoy the moderate spring weather and the revealing spectacle.

Subsequent research studies indicated that collegiate streaking events as reported in the news media peaked between March 1–9, 1974. Many campus incidents involved organizers, participants, reporters, TV crews, and control personnel. Streaking frequently involved planned activities by small groups belonging to preexisting social networks.

Ella Fitzgerald, accompanied by the Tommy Flanagan Quartet, sang at the MRF on July 20, 1973. On a damp evening, the jazz great delivered a repertoire of blues and scat numbers associated with artists such as George Gershwin, Duke Ellington, Cole Porter, and Billie Holiday. A company of young dancers trained by Katherine Dunham appeared on the bill prior to the Fitzgerald concert.

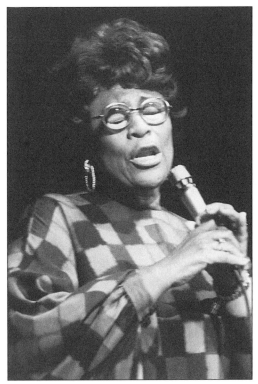

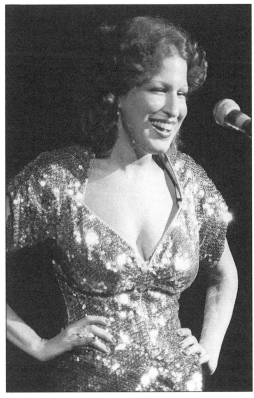

Five weeks later in the MRF season, on August 28, 1973, Bette Midler came to town. The Divine Miss M especially delighted the crowd with her revivals of 1940s songs.

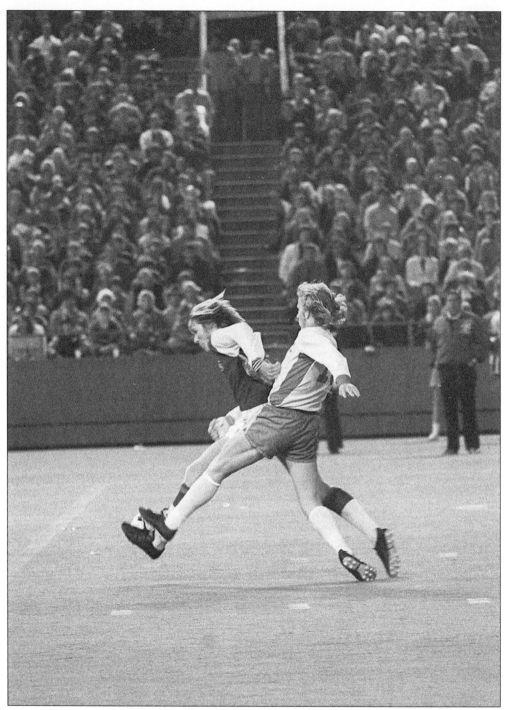

When the SIUE soccer team defeated St. Louis University, 1–0, in the Bronze Boot match played on November 8, 1974 at Busch Stadium, the Bills lost their number-one poll ranking, and the Cougars moved up to number three in the nation. Subsequently, the Cougars defeated Indiana University, but later lost a rematch against SLU in the second round of the NCAA Division I Midwest regional tournament.

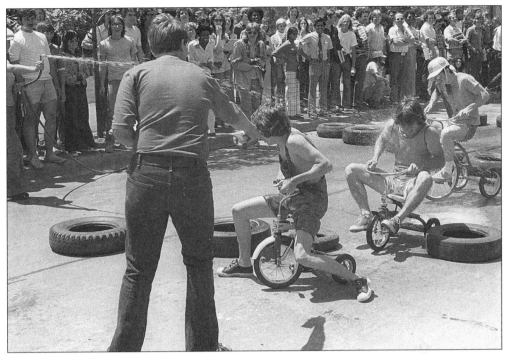

Springfest 1975 took place from May 12–17. The Emmett Kelly Circus performed in the Meridian Ballroom on May 14. The next day, students participated in the traditional and combative Hairpin Drive tricycle race.

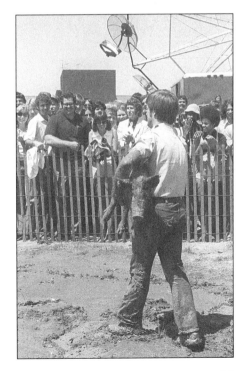

Also on May 15, 1975, contestants competed in a greased pig chase. Other activities included carnival rides, belly-dancing demonstrations, helicopter flights, and a concert.

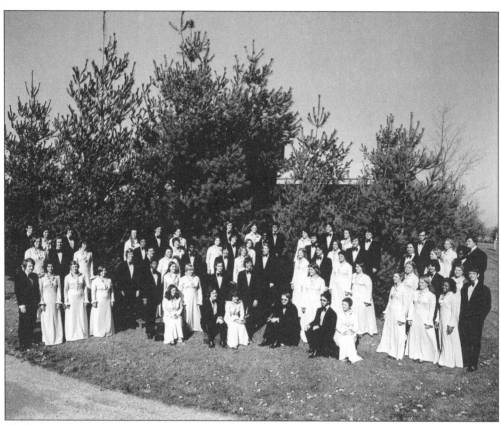

Prior to 1963, Herrold Headley directed groups of Collegiate Singers at Alton and East St. Louis and also the Chorophonic Society. With the arrival of Leonard Van Camp in the fall of 1963, the latter group of townspeople and students became the Community Choral Society. During 1965–1966, Van Camp initiated the Concert Chorale, pictured here on November 18, 1975.

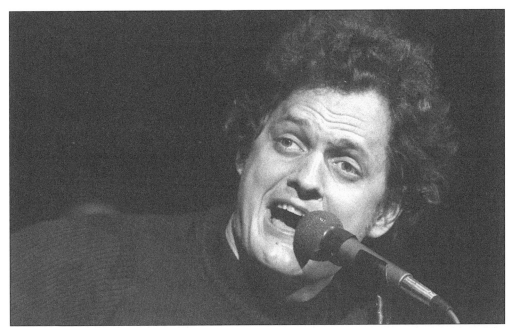

One critic used the term "spellbinding" in describing the concert by Harry Chapin on August 11, 1975. A crowd of six thousand persons heard Chapin perform, accompanied by his brothers Tom (guitar) and Steve (piano), plus Michael Masters on cello and John Wallace on bass.

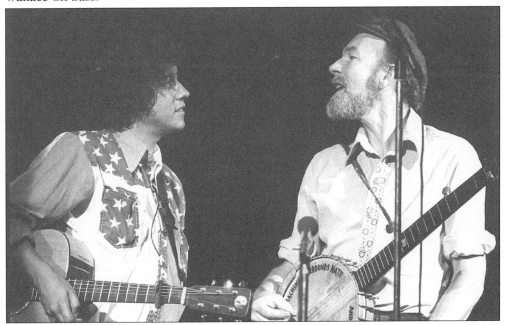

Arlo Guthrie (left) and Pete Seeger appeared at MRF on the same evening, August 6, 1975. Guthrie played acoustic guitar and piano. Seeger played acoustic guitar and banjo. Working together on some numbers and individually on others, the two men greatly entertained a crowd of seven thousand people who invited them back for two encores.

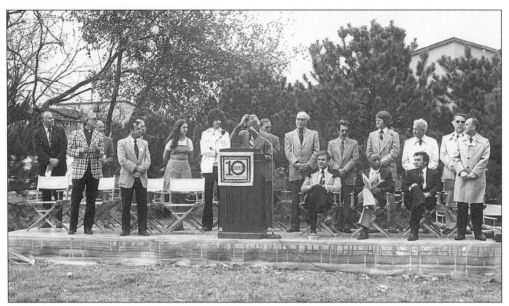

Construction began in late October 1973 for a second on-campus housing project, the Tower Lake II complex, consisting of 31 two-story buildings containing 224 two-bedroom and 24 three-bedroom units. Dedication (pictured here) of the additional buildings, situated north of the original Tower Lake complex, took place on October 17, 1975. The Commons Building was not completed until March 1977.

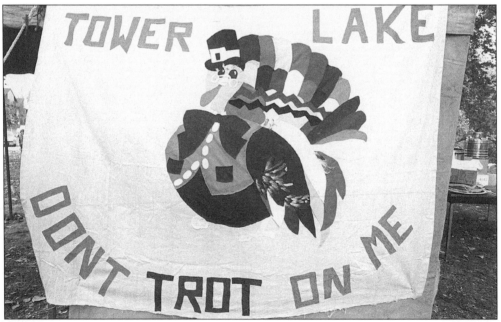

After a hatching egg appeared as a logo at the 1973 Tower Lake II groundbreaking ceremony, housing residents began to adopt the turkey as a community symbol. Some students formed a Tower Lake Turkeys volleyball team; others created a "turkey" flag. Residents borrowed a live turkey and displayed a turkey banner with the motto "Don't Trot on Me" at the 1975 dedication.

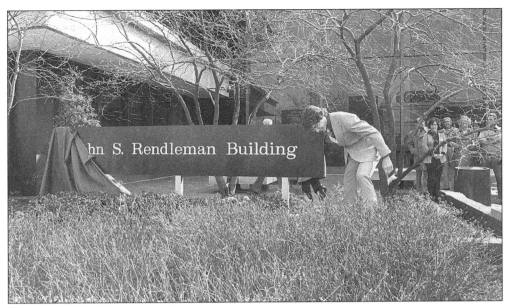

John Rendleman died of cancer on March 4, 1976. His family attended a March 17 ceremony naming the General Office Building in his memory. A veteran of numerous SIU posts, Rendleman became chancellor on June 21, 1968, and president on September 1, 1971. As chancellor/president during the years that the trustees made SIUE autonomous within the SIU system, Rendleman contended with state budget problems and Illinois Board of Higher Education restrictions.

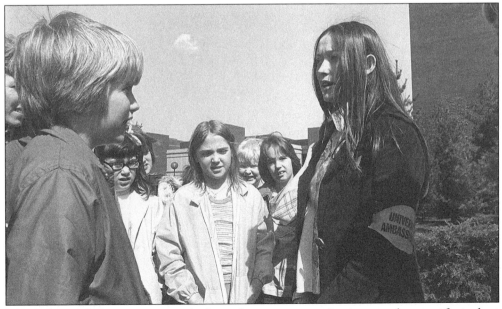

A member of the University Ambassadors, an organization made up of student volunteers who gave campus tours, spoke with visitors on April 1, 1976. Annette Mulvany Graebe, who founded the University Information Center in 1968, established the University Ambassadors group in 1969. In 1990, the University Ambassadors became the STARs (Students Assisting in Recruitment).

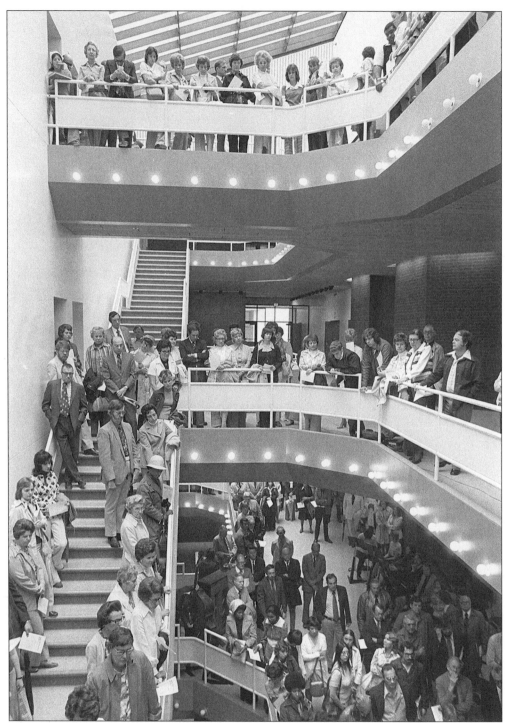

Acting President Andrew Kochman presided at the dedication event for Buildings II and III on May 13, 1976. The schools of Business, Nursing, and Education migrated from the University Center and the Rendleman and Science Buildings to the new structures. The two classroom buildings helped to alleviate a critical space shortage.

Donal Myer, pictured here in April 1973, joined the residence center faculty in 1958. A zoologist and parasitologist, Myer served as biological sciences chairperson and dean of the School of Sciences. Frank Kulfinski, professor of environmental studies, proposed the creation of a designated arboretum on campus during the 1980s. After Myer died on August 6, 1990, the Board of Trustees named the planned arboretum in his memory.

On May 28, 1963, the trustees approved the appointment of John Francis McDermott as the first research professor at Edwardsville. An authority on frontier art and the French in the Mississippi Valley, McDermott retired in 1971 and received an honorary doctorate in 1980. Chancellor Rendleman, McDermott (seen here on August 17, 1977), and Librarian John Abbott established Lovejoy Library's Center for Study of Mississippi Valley Culture in February 1970.

Andrew Kochman (left) joined the faculty in 1960 as associate professor and chairman of speech and theater. Kochman served as dean of fine arts, 1961–1970; vice chancellor for academic affairs, September 1970 through August 1971; and vice president and provost, August 1971 through March 1976. As acting president, Kochman withdrew his application for membership when a local country club denied admission to Emil Jason, assistant vice president for minority affairs.

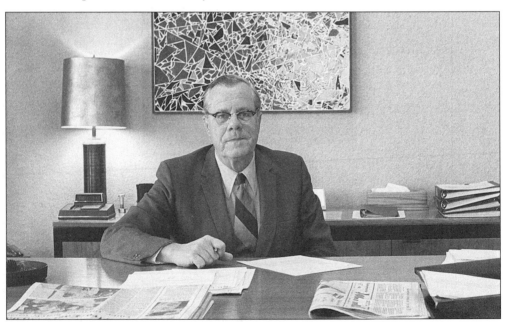

Senior Vice President for Planning and Review Ralph Ruffner accepted the role of acting president from October 14, 1976 to January 17, 1977. In all, Ruffner completed 13 years (1964–1978) of service as a vice president in several areas prior to his retirement.

Ivan Elliot Jr. (left) of the Board of Trustees introduced Kenneth "Buzz" Shaw as SIUE president on November 16, 1976. President Shaw lowered thermostats to save energy, initiated a planning process, created the Presidential Scholars program, kept the dental school in Alton, eliminated East St. Louis lower-division courses and the Experiment in Higher Education to satisfy Illinois Board of Higher Education and legislative demands, and privatized the Mississippi River Festival.

Warren Stookey and Mildred Arnold pioneered alumni services for the university. Stookey served as field representative and assistant director of alumni services. After the trustees decentralized SIU, Stookey became director of alumni services. He served SIUE from 1961 until his retirement in 1986. Arnold worked as an editorial writer for University News Service beginning in 1957 and, as editor, developed the alumni publications at SIUE prior to her retirement on October 1, 1996. She also contributed as advisor to the *Muse* yearbooks of the sixties.

On October 3, 1963, the trustees approved the acquisition of the Wagner Electric Corporation plant in Edwardsville to provide service and storage space on a "temporary" basis. Originally the N.O. Nelson plumbing factory complex, Wagner housed the library for a short period and art students and faculty until the completion of the Art and Design Building in 1993. In this photo at Wagner, Mark Sinclair and friend strolled together on December 16, 1976.

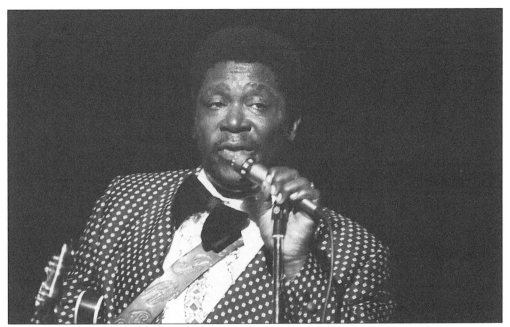

B.B. King played the guitar and delivered a selection of his greatest hits to the delight of a crowd numbering 4,500 when he visited the MRF on July 16, 1974. Fellow blues singer and guitar-player Muddy Waters preceded King on stage.

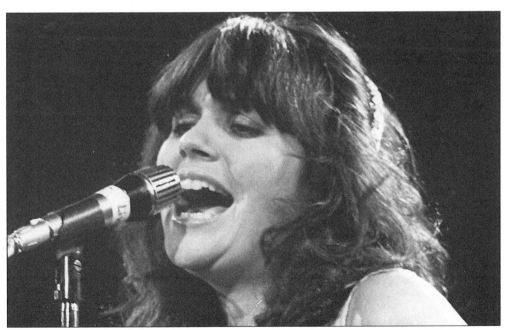

Country-rock singer Linda Ronstadt appeared at the MRF on August 9, 1976. Ronstadt reportedly took a position at center stage and held it for most of the evening, delivering song after song in rapid fashion to appreciative applause.

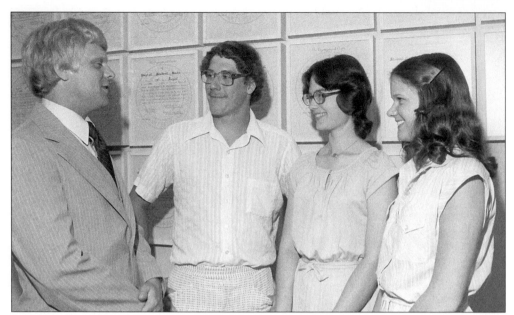

President Buzz Shaw announced on June 23, 1978 the selection of 20 high school graduates with high academic potential as Presidential Scholars. The announcement fulfilled Shaw's intention, first revealed in October 1977, to award four-year scholarships to targeted individuals in order to upgrade the quality of the student body. As shown here, Shaw (left) spoke with some of the Presidential Scholars on June 1, 1979.

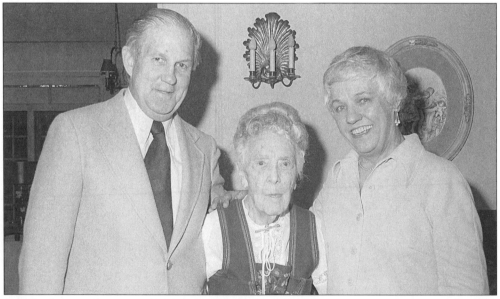

Jennie Latzer Kaeser received recognition from the Swiss government for her translation of a historical work about the community of Highland, *New Switzerland in Illinois*. In this May 11, 1977 photograph, Library Director John Abbott (left) and Friends Executive Secretary Sheila Stimson (right) congratulate Kaeser. A generous contributor to the Friends of Lovejoy Library, Kaeser accepted an honorary SIUE doctoral degree in June 1970.

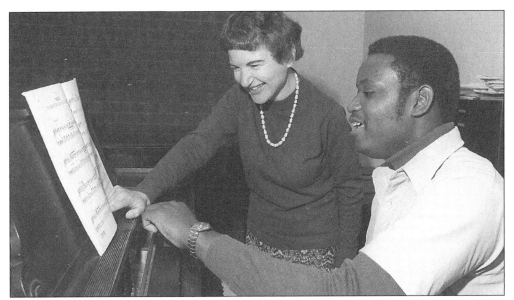

Artist-in-residence Ruth Slenczynska (shown here with her student Stan Ford on December 16, 1976) gave a piano concert at the MRF on July 6, 1969. Other noted pianists featured during the MRF inaugural season included Van Cliburn (July 11–12), Alicia de Larrocha of Spain (July 18–19), and Maestro Walter Susskind of the St. Louis Symphony. Cellist Leonard Rose (June 27) and violinist Itzhak Perlman (July 5) also performed in 1969.

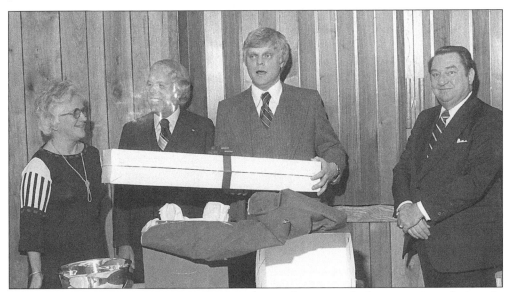

Colonel Charles Schweizer became assistant director of the SIU Foundation in September 1966 and associate director in June 1971. When the foundation decentralized in October 1973, Schweizer's title changed to executive director. At the time of his retirement in 1977, an independent SIUE Foundation came into being. Under Schweizer's leadership, from 1966 to 1977, SIUE Foundation assets increased from $10,000 to $ 1,338,000. Shown here, from left to right, are: Eleanor Schweizer, Colonel Schweizer, President Shaw, and SIUE Foundation President Jul Fischer.

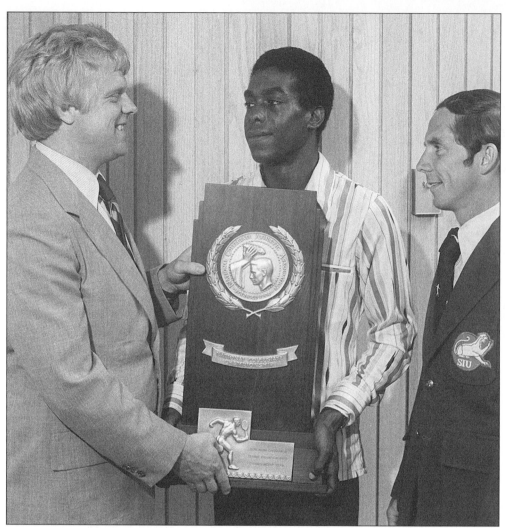

Juan Farrow (center) received congratulations from President Shaw (left) and Coach Kent DeMars after winning the 1978 NCAA Division II singles title. Tennis became a varsity sport in March 1974 under DeMars. Before DeMars resigned in 1984 to accept a job at the University of South Carolina, SIUE tennis teams achieved a 218–71 dual match record. DeMars coached seven singles champs, and his team won seven consecutive NCAA championships.

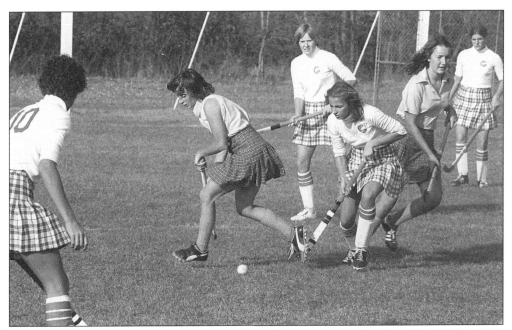

The SIUE field hockey team, coached by Cindy Jones, defeated Principia College on November 3, 1978 at Cougar Field. Overall, the Edwardsville team finished third in the field hockey championship tournament of the Illinois Association for Intercollegiate Athletics for Women. Jones, who founded the softball program in 1975, ultimately became director of intercollegiate athletics at SIUE in July 1988, succeeding Lynn Lashbrook.

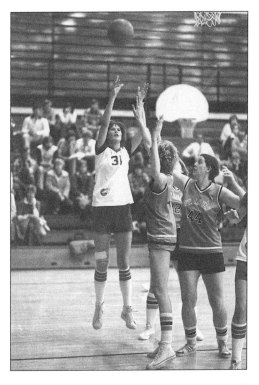

Senior Olivia Allen scored 17 points, but the SIUE women's basketball team (seen in this photo) lost to the St. Louis University lady cagers on December 3, 1979. Women's basketball began under the direction of Barbara DeLong in 1973. DeLong's 1973 basketball team, using the Alton gym for a home court, compiled a 4–11 record. Wendy Hedberg took over as coach for the 1979–1980 season.

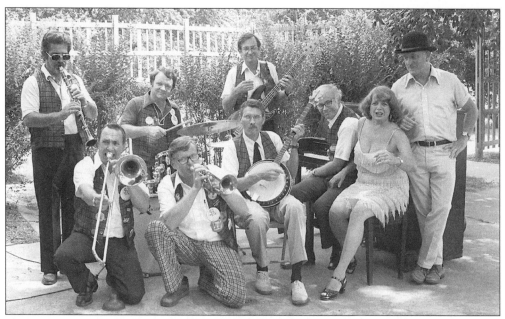

The Old Guys Jazz Band posed for a publicity shot prior to a performance, August 9, 1978. Faculty members at that time included, from left to right: Warren Brown (clarinet), Deane Wiley (trombone), Jim Hansen (drums), Dan Havens (coronet), Jack Ades (banjo), Ray Helsel (bass), plus Bill Feeney and Jean Kittrell (piano), and Lyman Holden (tuba). They came together in the spring of 1967, first appeared on November fifth, and debuted formally in November 1968. Proceeds from their appearances and album sales benefited a student loan fund.

Leonard Van Camp (pictured here on December 4, 1980) won the Great Teacher Award in 1994, as had his music faculty colleague, Dorothy Tulloss, in 1975.

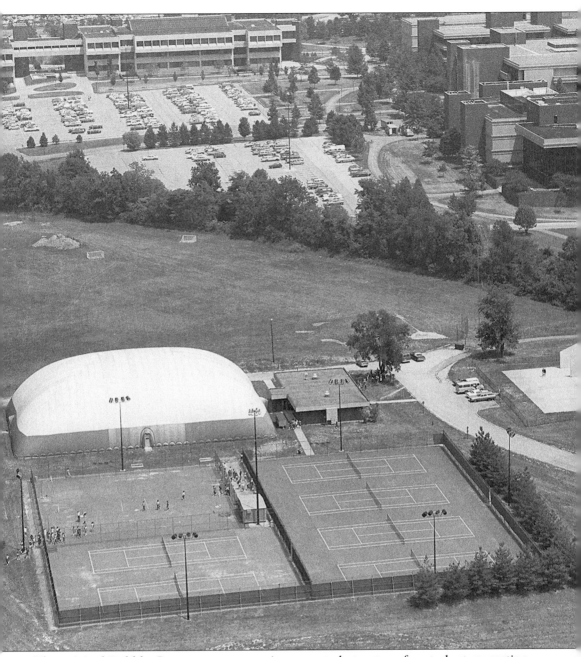

The original Bubble Gym, a temporary air-supported structure for student recreation and physical education classes, opened in November 1973. Photographed here on June 26, 1980, the Bubble Gym rose northwest of the Science Building, next to the handball and tennis courts. A windstorm destroyed the original Bubble Gym on July 20, 1981, and a heavy snow and ice storm collapsed its replacement on March 6, 1989.

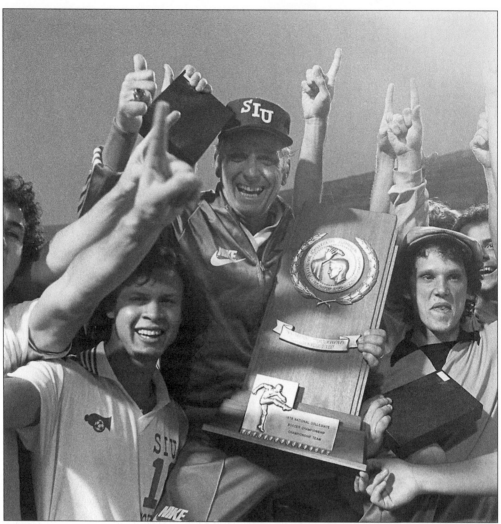

Bob Guelker recovered from heart bypass surgery in August in time to lead his soccer team to the NCAA Division I national championship on December 9, 1979. After turning aside the University of San Francisco and Penn State, the Cougars whipped Clemson University of South Carolina by a 3–2 score in a contest played in Tampa, Florida. The SIUE community officially celebrated the victory on January 15, 1980.

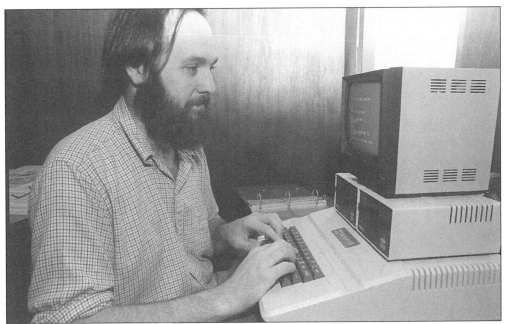

John Drueke, head of circulation, demonstrated the library's new Apple II Plus microcomputer, a gift from the Friends of Lovejoy Library, on October 18, 1979. During 1981, the library received funding for and began to install the statewide electronic catalog called LCS (Library Computer System). Based on a system at Ohio State, and adopted by the University of Illinois and the Illinois Board of Higher Education, LCS in conjunction with truck deliveries of books facilitated interlibrary loan activity.

Historian Allan McCurry, dean of the School of Social Sciences, became the first university archivist in 1979. Prior to his retirement in August 1985, he worked with Library Director John Abbott to preserve SIUE's historical records, publications, and photos. McCurry's successor, Louisa Bowen, served as archivist and librarian from 1985 through 1996. Upon Bowen's death, the university named the archives unit in her memory.

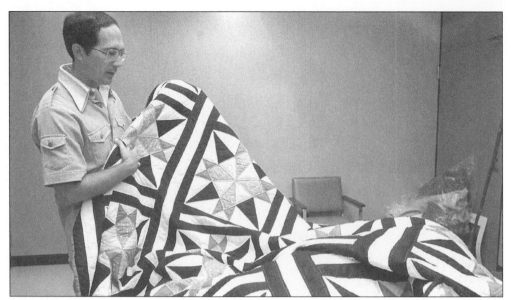

John Oldani, member of the English faculty and student of folklore, shared the 1974 Great Teacher Award with mathematician Marilyn Livingston. Oldani came to SIUE in 1969 and directed the American Studies program. He collected quilts and other folklore materials, and organized an annual quilt show in the Meridian Ballroom beginning on May 21, 1976. Oldani posed with a quilt in this June 25, 1980 photo.

Kamil Winter (left) and Patrick Riddleberger chat together in this photo, taken on May 9, 1980. Riddleberger, a historian, joined the university in 1960. He received the Great Teacher Award in 1981 and the President's Award of Merit in 1993. Winter became a visiting professor of mass communications in the fall of 1969. Then chief of television news in Czechoslovakia, Winter fled with his wife to America after the August 1968 Soviet invasion. Mass communications alumni established the Kamil Winter Endowment and Award in his honor.

Frederick Zurheide began teaching physics at the residence centers in 1958. He served as president of the Illinois Science Teachers Association from 1979 to 1981. Zurheide served as a member of an American Association of Physics Teachers (AAPT) delegation on a 1983–1984 visit to China and the Soviet Union. He posed for this image on April 24, 1980.

The School of Dental Medicine awarded its first doctoral degrees on August 9, 1975. In addition, SIUE began awarding the doctor of education degree in the instructional process on June 6, 1980. Pictured from left to right, are: Marcia Popp, Acting President Earl Lazerson, James Herrington, and Barbara Nierengarten-Smith participated in a special June 5 reception honoring the three graduates.

Earl Lazerson (right), provost and acting president, succeeded Buzz Shaw (left) as president effective July 10, 1980. Lazerson steered SIUE through state budget woes, reallocations, and reorganizations. He followed a policy of conciliation with the Illinois Board of Higher Education. Lazerson promoted regional development and initiated the Arts & Issues series, exchanges with China, Excellence in Higher Education grants to faculty, and Preview SIUE for high school students.

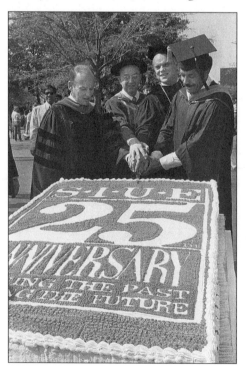

President Lazerson arranged for a celebration of the 25th anniversary of the opening of SIUE. President Emeritus Clark Kerr of the University of California delivered the convocation address on September 30, 1982 to start a year of activities. Shown from left to right, are: President Lazerson, President Kerr, SIU system Chancellor Buzz Shaw, and trustees board chair William Norwood combined to cut a ceremonial cake.

Four

ADAPTATION AND STABILIZATION

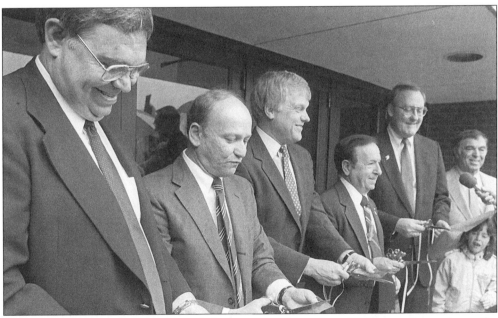

State budget problems postponed the construction of an SIUE gym throughout the 1970s. State Senator Sam Vadalabene led the legislative crusade that finally initiated planning in 1979. Governor James Thompson paid tribute to Senator Sam's tenacity at the May 7, 1984 dedication of the Vadalabene Center, an event in the first Founder's Celebration. Vadalabene's gym fulfilled a deathbed promise to John Rendleman. Shown here, from left to right, are: trustee Dr. George T. Wilkins, President Lazerson, Chancellor Shaw, and Senator Vadalabene. Governor Thompson cut the ribbon.

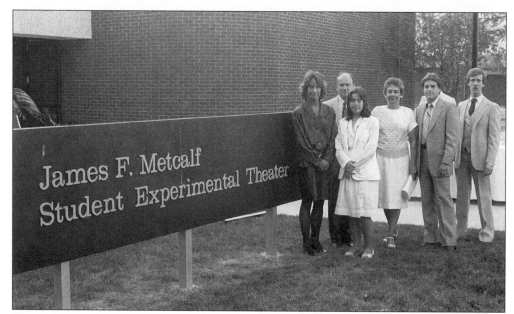

Plans for a performance facility for student-initiated productions to replace the Quonset Hut received approval in 1980. Construction took place during 1983 on the handball site, south of the Bubble Gym. The theater opened on May 25, 1984. The trustees named the student experimental theater in memory of longtime budget director James Metcalf. His family attended the May 22, 1985 dedication seen here.

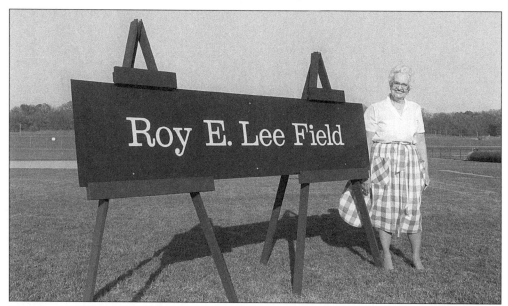

President Rendleman threw out the first pitch at the dedication of the Cougar Field baseball diamond at the corner of Bluff and Poag Roads, April 26, 1972. Coach Roy Lee resigned in September 1978, with a 237–145–4 record that included eight NCAA regional and three NCAA Division II World Series appearances. Lee died on November 10, 1985. A dedication event renaming Cougar Field in honor of Roy Lee took place during a doubleheader on April 26, 1986.

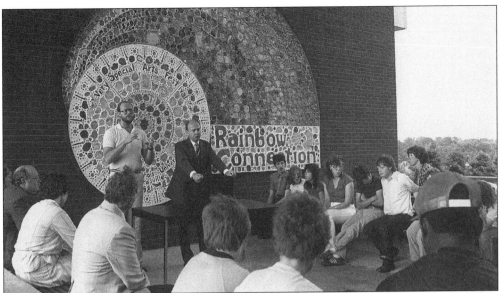

SIUE hosted its first Very Special Arts Festival in October 1978. The June 8, 1982 festival featured the dedication of a giant mosaic, known as the Rainbow Connection, affixed to the south façade of Building III. Diane Savoca, who with Dona Anderson directed the festival, thanked the special education students who made the tiles in the mosaic for their craftsmanship and schoolteachers Pat Winkle and Pat Imming for their concept. Ray Althoff (left) signed President Earl Lazerson's speech.

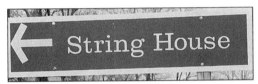

The String House, one of the original campus structures, also known as Tract House 142, stood north of the MRF grounds. Before moving there, John Kendall and the String Music Program occupied quarters in Tract 128, near the Quonset Hut.

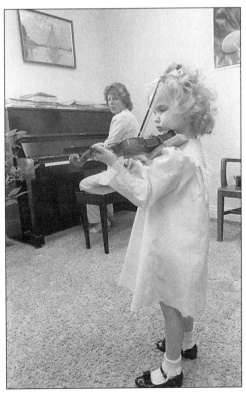

Violinist John Kendall joined the faculty in 1963 and retired in 1987. He developed the string music program at SIUE and was a pioneer in introducing the Suzuki method of string instruction to children in America. Kendall received a Distinguished Service Award from the university at the May 7, 1994 commencement. This young string student posed for the photographer on April 7, 1986.

Chimega retired as the SIUE mascot in the summer of 1982, after a long life of service to the university. Her intelligence and calm demeanor made her the perfect mascot. A three-month-old cub, Kyna, became her successor. Chimega died on March 12, 1985, at the advanced age of 17.

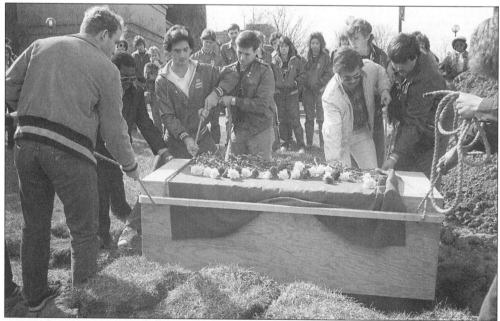

Many of Chimega's friends and admirers took part in a burial ceremony at a site near the small lake east of Building II. Even before Chimega's death, administrators had begun to be concerned about the costs of maintaining a live mascot, including liability issues. Dissention had become a problem within the Cougar Guard, and the cougar cage needed to be rehabilitated.

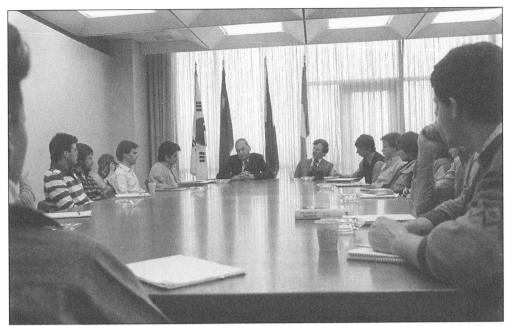

President Lazerson initiated the Arts & Issues series of speakers and performing artists during the 1985–1986 academic year. The first speakers included former ambassador George Ball (October 23); economist John Galbraith (December 3); and Edwin Newman, veteran NBC television journalist. In this photo, Newman, who appeared on January 23, 1986, met with students. Richard Walker became coordinator of Arts & Issues in July 1986.

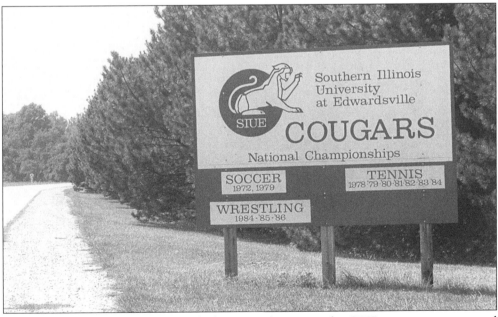

This sign, emblematic of national championships won by SIUE sports teams, stood along East University Drive.

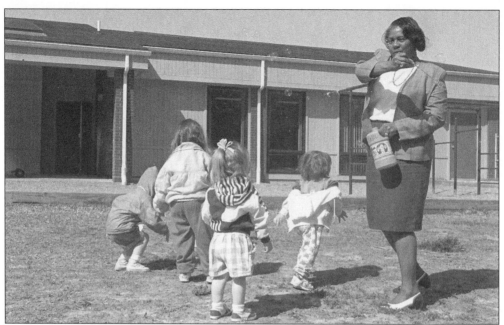

The Late Starters Club of nontraditional age students established a campus child-care center beginning on September 25, 1969. Groundbreaking took place for a new Early Childhood Center facility on September 27, 1985. Dedication of the completed 5,100-square-foot ECC followed on April 24, 1986. Sandra LaVernn Wilson, pictured here with young students at the center, served as director of the ECC from June 6, 1971, until her retirement on February 29, 2000.

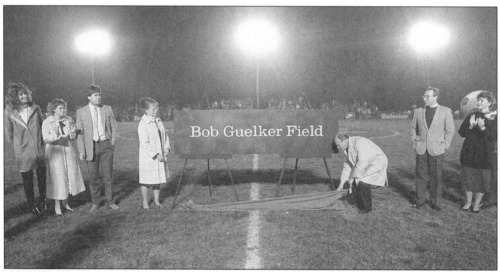

Coach Bob Guelker, founder of the SIUE soccer program, died on February 22, 1986. Guelker became the third collegiate coach to win three hundred games and achieved a lifetime 311–76–26 coaching record. His record at SIUE totaled 216–67–21. Guelker took Cougar teams to the NCAA tournament fourteen consecutive times and won titles in 1972 (Division II) and 1979 (Division I). A November 1, 1986 ceremony marked the naming of Bob Guelker Field.

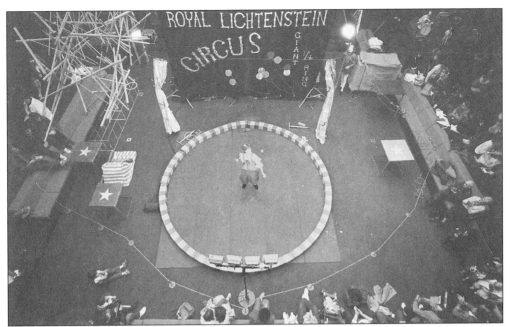

The Royal Lichtenstein Circus performed at SIUE on November 12, 1986. The circus featured jugglers, balancers, acrobats, mimes, escapologists, and trained animal acts.

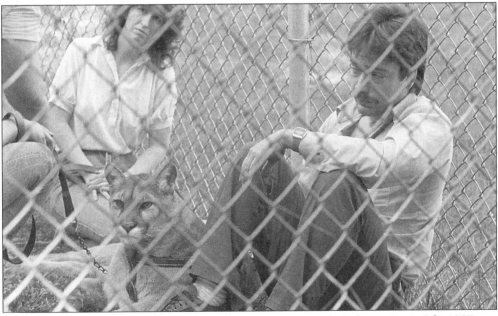

When the administration gave Kyna away to an animal park on June 26, 1987, an explosion of disapproval and bad publicity followed, but to no avail as the decision held. The deportation of Kyna served as a symbol of changing times and the impact of outside forces on SIUE. The ambitious dreams of See, Morris, and Rendleman encountered fiscal and political constraints. The state experienced economic difficulties during the 1970s and 1980s, and established the Illinois Board of Higher Education (IBHE) to make coordinated resource allocation recommendations to the legislature and governor.

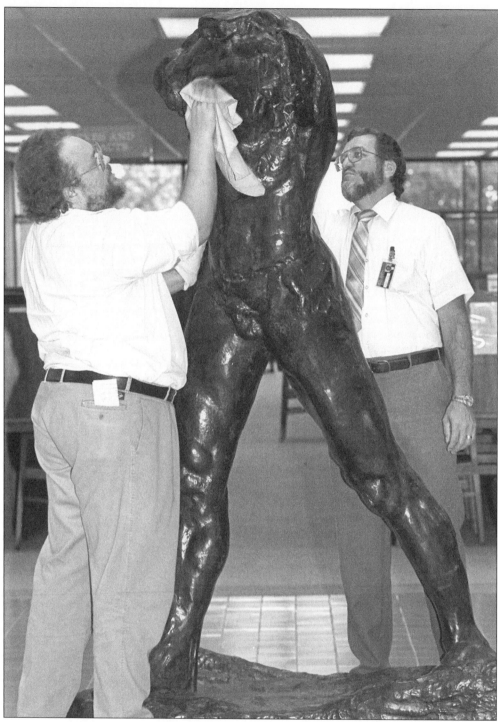

Eric Barnett (left) and Mike Mason of the University Museum cleaned the Walking Man statue in the lightwell of Lovejoy Library on July 12, 1989. The 7-foot-high bronze casting of Auguste Rodin's famous work had been acquired by purchase in 1965 from Rene Dreyfus of Paris.

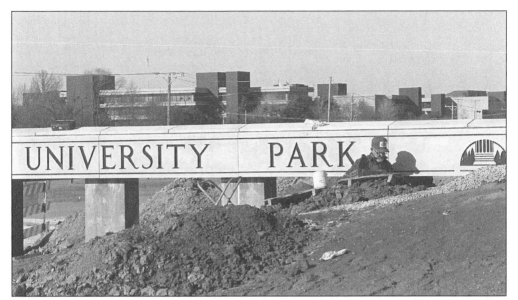

President Lazerson announced on January 28, 1986 that Governor Thompson had released funding to create University Park as a home for cooperative research ventures, training programs, and incubation facilities. Groundbreaking occurred on April 7, 1989. The federal Department of Agriculture announced in May 1997 the release of $1.5 million in funding for an ethanol pilot plant or research facility in University Park.

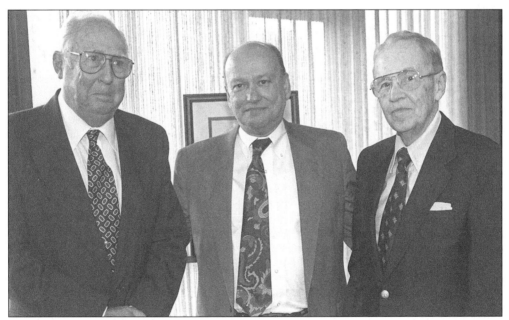

Harold See (left), President Lazerson (center), and William Going (right) posed on May 19, 1992, when the two SIUE pioneers received presidential awards of merit. See served as the human catalyst in the early movement to secure a university for the Metro East, and President Morris found See's local popularity threatening. Because See advocated a separate curriculum for the Southwestern campus, Morris fired him immediately after passage of the 1960 bond issue.

Rudolph Wilson joined SIUE in 1969 as a lecturer in the Education Division. A recipient of the alumni association's Great Teacher Award in 1973, Wilson received an appointment as the assistant provost for cultural and social diversity on August 1, 1997. Wilson and his wife, Sandra LaVernn Wilson of the Early Childhood Center, inspired generations of students to value education and to respect the feelings and the cultures of other people.

Don McCabe (standing) joined the faculty in 1969. A political scientist and student of environmental issues, McCabe presented the fifth session of the University Seminar at Edwardsville series on March 12, 1974. McCabe, who enjoyed a reputation as a well-prepared and effective teacher, served as chairman of political science until his retirement from the university in 1997.

Five

TO THE NEXT LEVEL

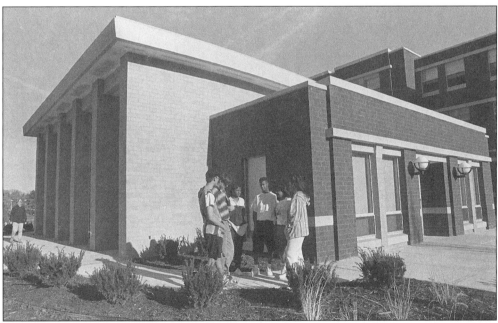

Years of planning for additional on-campus housing came to fruition at the October 13, 1994 dedication of the first student residence hall at SIUE. The three-story facility, initially occupied on August 19, included bedrooms and baths, study rooms, lounges, meeting rooms, a computer lab, a laundry, a multi-purpose room, a learning resource center, and storage and office space. The building rose on the former site of the university police operation.

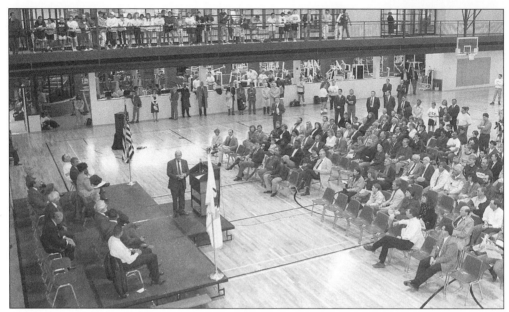

The official grand opening and dedication of the Student Fitness Center took place on April 1, 1993. The 50,000-square-foot addition to the west side of the Vadalabene Center contained four multipurpose courts, plus a jogging track, weight training center, aerobics room, wellness center, child care room, lounges, meeting rooms, and offices. The new student recreation facility served as the replacement for the ill-fated Bubble Gym.

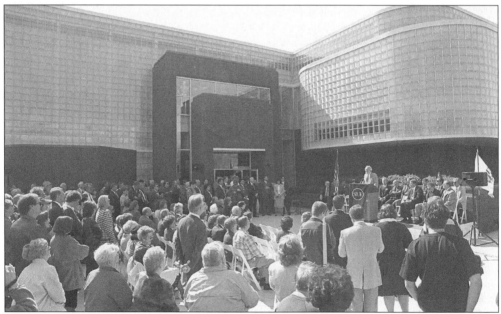

When Governor Jim Edgar announced the release of $4.7 million for construction of an Art and Design Building in October 1991, members of the faculty could scarcely believe the news. Since the acquisition of the Wagner complex in 1963, they had lived in the hope of new quarters through three decades. The official opening of the nearly-finished building, situated west of the Religious Center, took place on October 14, 1993.

An annual event, and the successor to Winterfest, the Goshen Ocean consisted of several tons of sand brought into the University Center's lounge to serve as wintertime entertainment for snow-weary students. The first Goshen Ocean, which took place on February 20, 1980, included a muscle man contest and a sandcastle building contest.

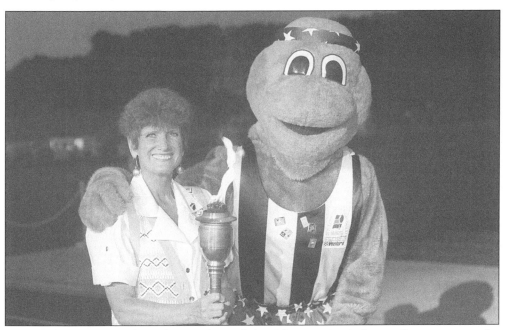

During the summer of 1994, SIUE hosted the Olympic Festival wrestling events at the Vadalabene Center (July 2–6) and the track and field events at the new stadium (July 8–10). Many members of the alumni association and area residents served as volunteers at festival events. Here, SIUE Alumni Association President Judy Verseman posed with Speedy Smith, festival mascot.

117

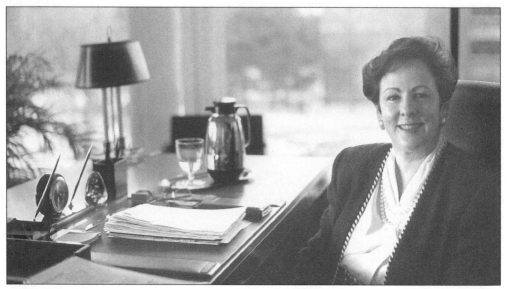

Nancy Belck became the first woman to assume the presidency of SIUE on January 1, 1994. She fostered an image of openness, collegiality, and diversity. Belck appeared eager to leave her office and discuss issues with members of the university community, and she invited people to chat with her while walking around the campus. She worked hard at presenting the image of an energized, dynamic SIUE to the public. Belck resigned to accept appointment as chancellor of the University of Nebraska at Omaha effective September 1, 1997.

President Belck (right) helped students move into the new residence hall on August 19, 1994. Belck also presided at the September 14, 1995 dedication of the new music wing addition to the south side of the Communications Building. Begun on May 16, 1994, the music wing consolidated departmental classrooms, studios, practice rooms, and faculty offices.

Marie Robertson and Dale Blount viewed one of 25 computers and printers donated by the Friends of Lovejoy Library. For this project, the national organization Friends of Libraries USA recognized the Friends of Lovejoy Library as the top academic library friends group in the country in 1995. The Friends of Lovejoy Library had received the FOLUSA award in 1990 for overall excellence in fundraising.

Luke Snell (at right, seen here with a student), with the assistance of prominent alumnus Ralph Korte, worked to establish the degree program in construction at SIUE. His construction students regularly excelled in competitions sponsored by the American Concrete Institute. Snell also developed concrete construction programs for grade school and middle school children. His sustained efforts over many years earned Snell the 1997 Great Teacher Award.

Three students enjoyed a beautiful spring day in April 1995.

The women's cross country team (shown here on September 6, 1997) began competition under the leadership of Lori Starks on September 15, 1979. Earlier, John Flamer joined the university in September 1968 as the first cross country coach. His Cougars defeated Millikin University in Decatur in their first intercollegiate cross country meet on October 5, 1968. Flamer coached cross country for eighteen years (until March 1, 1986) and track for nine.

During 1997, work proceeded on a new ground-level greenhouse to replace the deteriorating greenhouse located on top of the Science Building. The 30-year-old rooftop greenhouse no longer met the needs of science classes. Marian Smith of Biological Sciences and foundation board member John Anderson attended the October 30, 1997 dedication ceremony.

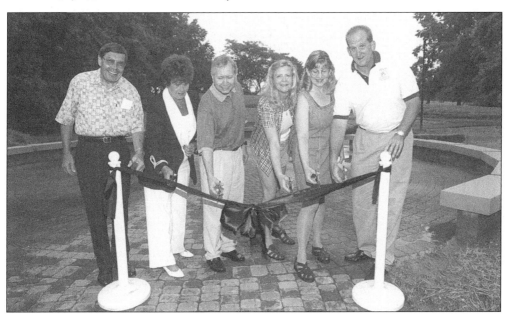

Work began on the Donal Myer Arboretum in May 1996. SIUE Foundation board members Charles Tosovsky and Rita Hardy played major roles in raising private funds for the arboretum. One bridge for the project, constructed of North Carolina pine by Enwood Structures of Tennessee, weighed almost 20 tons and had a span of 100 feet. Dedication of the Myer Arboretum (seen in this image) took place on July 7, 1998.

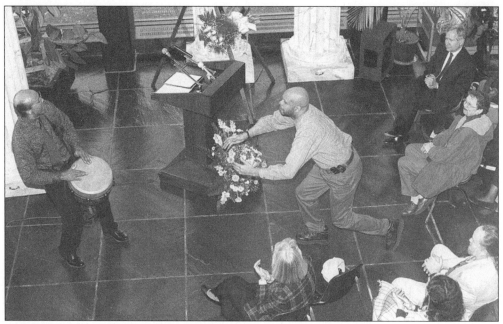

On October 9, 1997, the trustees approved new names for several campus structures and sites, including Founders Hall (Building II), Alumni Hall (Building III), Woodland Hall (first residence hall), Prairie Hall (second residence hall), Cougar Lake (Tower Lake), and Cougar Village (Tower Lake apartments). In a ceremony held on March 3, 1999, the Communications Building became Katherine Dunham Hall to honor that respected dancer and teacher, and dancers from the Performing Arts Training Center participated in the dedication.

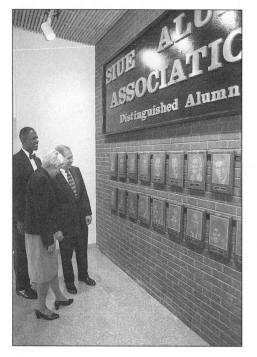

Chancellor David Werner presided at a brief ceremony on August 7, 1998 that marked the re-naming of Building III as Alumni Hall. Pictured, from left to right, are as follows: Judge Milton Wharton, distinguished alumnus of the year 1977; Dee Joyner, distinguished alumnus of the year 1984; and Chancellor Werner. In this photo, they are examining historical wall plaques at the conclusion of the ceremony.

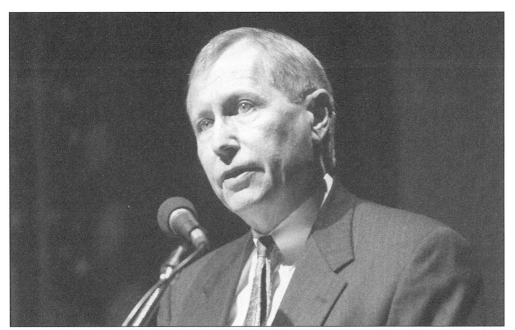

David Werner became chancellor of SIUE on September 1, 1997, succeeding Nancy Belck. Werner, a professor of management information systems and operations management, joined the business faculty in 1968. He served as dean of business from 1975 to 1987, and thereafter as provost and vice president/vice chancellor for academic affairs. In this photo, Werner addressed the university community on September 23, 1998.

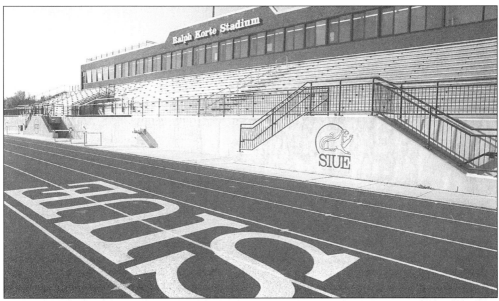

Ralph Korte led the effort to construct a new stadium surrounding Bob Guelker Field as a venue for the 1994 Olympic Festival track and field competition. Thanks to a public/private partnership, the state made a grant to the City of Edwardsville, and the city developed the stadium for the university. To honor his longstanding and generous support of SIUE, the trustees named the new stadium for Ralph Korte on June 11, 1998.

123

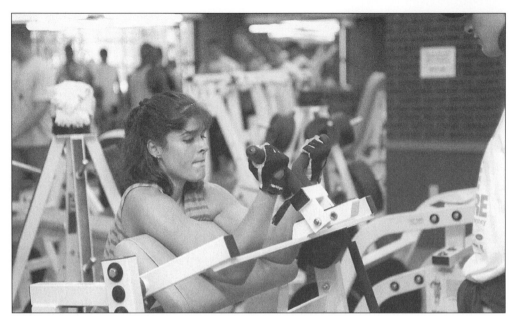

The Student Fitness Center proved extremely popular with students, faculty, and staff members. In July 1997, the trustees approved an addition to the center. Construction began in the fall of 1998, and the 4,100-square-foot addition opened on September 9, 1999. The addition included a room dedicated to free weights and substantially added space for cardiovascular training equipment.

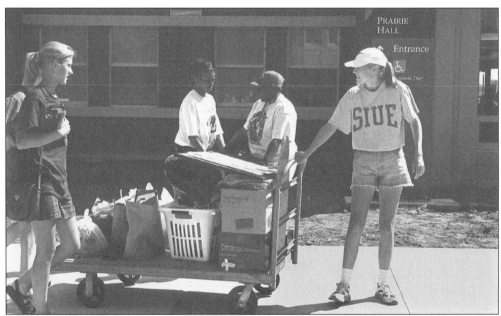

The trustees gave project approval for construction of a second student residence hall in July 1997 and awarded construction contracts in September of the same year. Prairie Hall opened its doors to freshmen students, as seen in this image, on August 21, 1998. The capital project for Prairie Hall included funding for continued renovation of Cougar Village and also for University Center cafeteria improvements to serve additional residents.

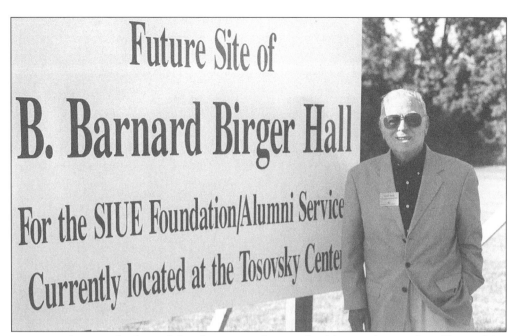

B. Barnard Birger facilitated development of a new building to house the offices of the alumni association and the SIUE Foundation. The groundbreaking ceremony (shown here) for B. Barnard Birger Hall took place on May 27, 1999. Previously, in 1973, Mr. and Mrs. Ernest Tosovsky donated their home and surrounding property to house the foundation. Ernest Tosovsky received the SIUE Distinguished Service Award in 1971.

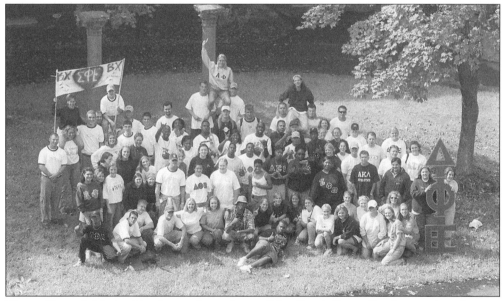

The artifacts visible in this photo of members of the Greek Council, taken against the east wall of Lovejoy Library on September 21, 1998, came from the Louis Sullivan Collection, University Museum. Sullivan (1856–1924) helped establish the style called the Chicago School of Architecture. Richard Nickel, architectural historian, rescued Sullivan building ornaments from destruction and donated many of them to the university.

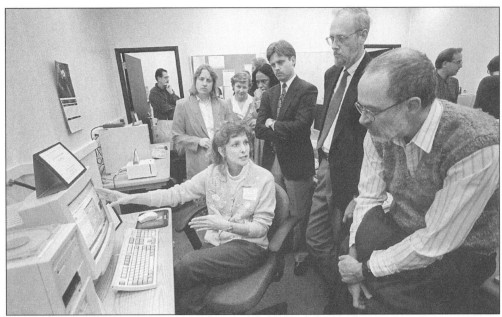

Chancellor David Werner took part in opening the Faculty Technology Center on December 15, 1997. In this view, from left to right, graduate student Laurie Corwin spoke with Deb Bier, Kathy Behm, Ina Sledge, Dwight Smith, Harlan Bengtson, and Ron Schaefer. Library and Information Services created the Faculty Technology Center to assist faculty members in learning about and making use of advanced technological tools in their teaching and research.

John Abbott served as founding director of Lovejoy Library from 1960 to 1981, and thereafter as special collections librarian until 1997. Abbott helped to plan the library building, developed its collections, nurtured the Friends of Lovejoy Library support organization, and initiated bibliographic instruction. Abbott's son, John (left), and Chancellor Werner unveiled a name plaque at the dedication of the library auditorium in his honor on March 17, 2000.

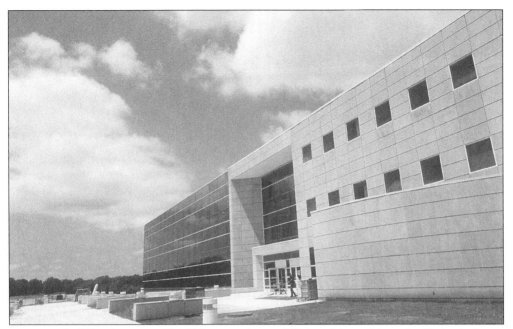

In June of 1997, Governor Jim Edgar made a publicity visit to Edwardsville in order to present Chancellor Belck with a symbolic $21.3 million check for a new Engineering Building. Construction on the facility began in June 1998. Located to the north of the Art and Design Building, the Engineering Building was dedicated on September 13, 2000.

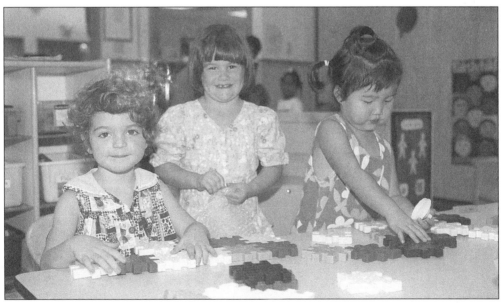

Catherine Elizabeth Kerber, Amy Scroggins, and Christine Yan, classmates in the Yellow Room of the Early Childhood Center, posed in the summer of 2000 for photographer Denise Macdonald. "Once upon a time, there was a little girl who lived in a house made of bricks in the Great Dark Wood with her mommy and her daddy and a little kitty named Minou"

Bill Brinson, a mass communications graduate of SIUE, returned in August 1986, to become campus photographer upon the retirement of Charlie Cox. A veteran photojournalist who had served as director of photography for the *St. Louis Globe-Democrat*, Brinson brought both technical skill and a sense of humor to the difficult task of succeeding the popular veteran Cox.

Charles Cox came to the university in 1961 as a combination news-photography staff member. For the next 25 years, day by day, he chronicled the establishment and evolution of SIUE through his lens. Through his photography, Cox made the new university visible to people throughout the region and the state. Cox took a photograph of every "first," every building, every sports competition, every cougar, and every pretty woman at SIUE between 1961 and 1986.

ACKNOWLEDGMENTS

We would like to thank Dean Jay Starratt of Library and Information Services (LIS) who has supported us in several research projects involving the history of SIUE. We are grateful to Bill Brinson for scanning each of the images in this book. Angela Collins Custer and Amanda Bahr-Evola provided invaluable assistance. Lovejoy Library Director John Abbott, and archivists Alan McCurry and Louisa Bowen, spent decades gathering together the university records essential to our research, and we acknowledge their vital contribution. Most importantly, we thank our talented university photographers, Charles Cox, Denise McDonald, and Bill Brinson. We are profoundly grateful to Charlie, Denise, and Bill for the remarkable visual legacy they have captured through their artistry, their technical expertise, and their eagerness to help others to see and to understand. In addition, we thank Chancellor David Werner for his continuing interest in the history of our university—SIUE.